Rebel Song
Faces of Irish Music

Andrew Catlin

Rebel Song

Thanks to: Shane MacGowan, Victoria Mary Clarke, Frank Murray, Danny Pope, Sinéad O'Connor, John Reynolds, Christy Moore, Jem Finer, Spider Stacey, Andrew Ranken, James Fearnley, Rory Gallagher, Darryl Hunt, Barry McIlheney, Philip Hall, Olga Mamonova, Siobhan MacGowan, Gerry Boyle, Russell Baker, Janice Long, Monika Döring, Gary Sheehan, Cait O'Riordan, Stephen Malit, Mike Oldfield, Kirsty MacColl, Bono, Andy Cowles, Allan Jones, Colin Irwin, Philip Chevron, Ronnie Drew, Volker Wolf, Terry Woods, Steve Mack, Carol Clerk, Mat Smith, Mike Oldfield, Raymond Gorman, Tom Sheehan, Alexandra Drawbridge, Dave Jordan, Charlie MacLennan, Terry Edwards, Gary Sheehan, Seamus McGarvey, Sean O'Hagan, Steve Pyke, Terence Pepper, Filthy McNasty's, Patrick Jones, Stephanie West, Ali Newling. Special thanks to Aisling O'Connor.

For original text references and full texts please refer to Google.

Cameras by Rolleiflex, Canon, Hasselblad, Leica
Lenses by Carl Zeiss, Canon
Tripods by Linhof
Camera Bags by Billingham, Crumpler

Film by Kodak, Agfa, Fuji, Ilford
B&W Developer HC110 by Kodak
Stop by Agfa
Fixer by Ilford
Developing Tanks and Spirals by Paterson
Spinner by Zanussi
Photographic Paper Record Rapid by Agfa
Drying Cabinet by Marrutt
Film Sleeves by Kenro
Scanning Creo iQsmart 3 by Danny Pope, Andrew Catlin
E6/C41 Processing by Metro, Joe's Basement, Graham Nash Labs
BW Processing and Printing by Danny Pope, Volker Wolf, Andrew Catlin
Colour Printing by Danny Pope, Alexandra Drawbridge
Post Production Lightroom, Photoshop
Layout InDesign
Hardware Apple, SanDisk
Printed by Lightning Source

ISBN 978-1-9998818-5-6

Rebel Song

Nearly 4,000 vessels carrying food left Ireland for ports in England during "Black '47" while 400,000 Irish men, women and children died of starvation.

The food was shipped from some of the worst famine-stricken areas of Ireland, and British regiments guarded the ports and granaries to guarantee British merchants and absentee landlords their "free-market" profits. All food depots except on the western seaboard were closed, public works were suspended, and local relief committees were forbidden to sell or distribute food at less than prevailing prices - which were inflated because of scarcity and speculation.

In mid-1847, Parliament amended the Poor Law to forbid public relief to any household head who held more than a quarter-acre of land and refused to relinquish possession of the land to the landlord. The choice was either become homeless or starve.

Charles Trevelyan, assistant secretary of the treasury and director of government relief proclaimed that:

"The great evil with which we have to contend is not the physical evil of the famine, but the moral evil of the selfish, perverse and turbulent character of the people."

Trevelyan was knighted in 1848 "for his services to Ireland".

Rebel Song

Mary of Dungloe
Pádraig Mac Cumhaill

Oh then fare thee well sweet Donegal,
the Rosses and Gweedore,
I'm crossing the main ocean
where the foaming billows roar,
It breaks my heart from you to part
where I spent many happy days.
Farewell to kind relations,
I am bound for Amerikay.

Oh then Mary you're my heart's delight,
my pride and only care,
It was your cruel father
would not let me to stay here,
But absence makes the heart grow fond,
and when I am over the main,
May the Lord protect my darling girl,
'till I return again.

And I wish I was in sweet Dungloe
and seated on the grass,
And by my side a bottle of wine,
and on my knee a lass,
I'd call for liquour of the best,
and I'd pay before I'd go,
And I'd roll my Mary in my arms,
in the town of sweet Dungloe.

1

Christy Moore "When I started singing, 50 years ago, there was no such thing as songwriters. Think about all the songs handed down through the millennia – it just didn't dawn on me to view myself as a songwriter. Songs were things you collected, cherished and passed on. I would travel to Galway or Roscommon or Manchester just to track one down."

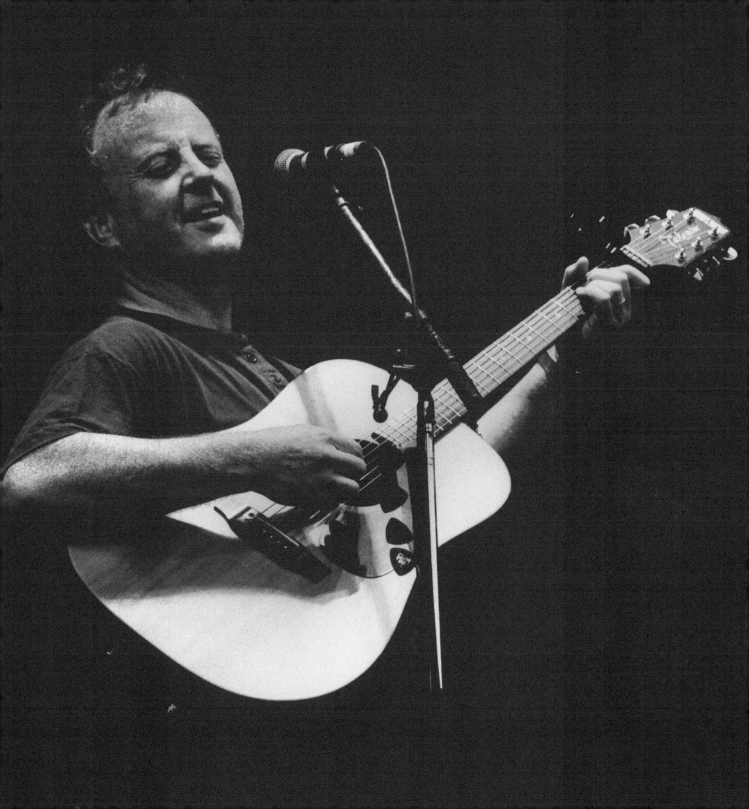

The Foggy Dew
Traditional

As down the glen one Easter morn
To a city fair rode I
There armed lines of marching men
In squadrons passed me by
No fife did hum, no battle drum
Did sound its dread tattoo
But the Angelus bells o'er the Liffey's swell
Rang out through the foggy dew

Right proudly high over Dublin town
They hung out the flag of war
'Twas better to die 'neath an Irish sky
Than at Suvla or Sud el Bar
And from the plains of Royal Meath
Strong men came hurrying through
While Britannia's huns with their long-range guns
Sailed in through the foggy dew

'Twas Britannia bade our wild geese go
That small nations might be free
But their lonely graves are by Suvla's waves
On the shore of the gray North Sea
But had they died by Pearse's side
Or fought with Cathal Brugha
Their names we would keep where the Fenians sleep
'Neath the shroud of the foggy dew

But the bravest fell, and the requiem bell
Rang mournfully and clear
For those who died that Eastertide
In the springing of the year
And the world did gaze in deep amaze
At those fearless men, but few
Who bore the fight that freedom's light
Might shine through the foggy dew

Shane MacGowan (The Pogues) "I'm just following the Irish tradition of songwriting, the Irish way of life, the human way of life. Cram as much pleasure into life, and rail against the pain you have to suffer as a result."

"My crusade was to make Irish music hip again, and to build Irish esteem. To let the world know what an incredible wealth of culture we've contributed for such a small nation."

Spider Stacey (The Pogues) "One day we were round at a friend's house and Shane picked up a guitar and started singing Poor Paddy Works on the Railway at about 900 miles an hour... It really was so glaringly obvious that the only surprising thing was that nobody had thought of it before."

Jesse Malin "I saw the Pogues for the first time at their New York City debut, at a club in Chelsea called Danceteria. It was pretty intense, and people were going wild to this mix of Celtic folk and punk rock. I'd never seen anything like it before."

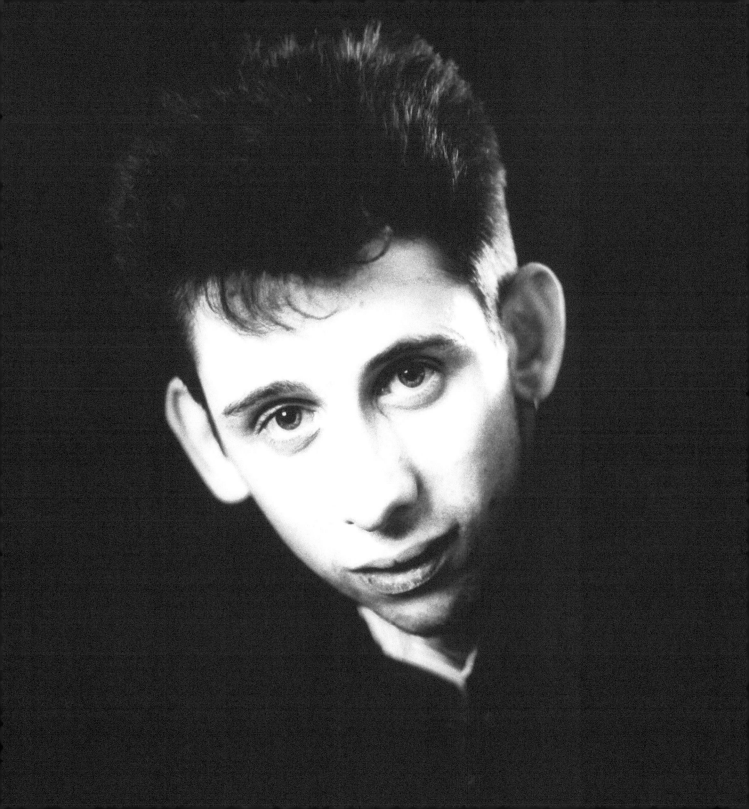

You are a moonchild and, pretty soon child
I've got that feeling that
I'm gonna make you smile forever if I can
Just give me a sign and I'll show you my plan
You are a blue child, forever true child
You know that I'll try to
Paint the skies blue forever if I can

Rory Gallagher "Blues players don't mess around with the guitar, they hit the bloody thing!"

"It seems a waste to me to work and work for years and just turn into some sort of personality."

Johnny Marr "Rory Gallagher has exerted a huge influence on me. He taught me chord changes and how to conduct myself on and off the stage. I owe him."
"He wasn't musically blinkered, he saw merit in everything, it was liberating."

Dermot Stokes "The hugely important thing that Rory did early on in his career was to establish that an Irish band could form, play original material – could do it in Ireland first of all, then could take it to London, then Europe and around the world."

3

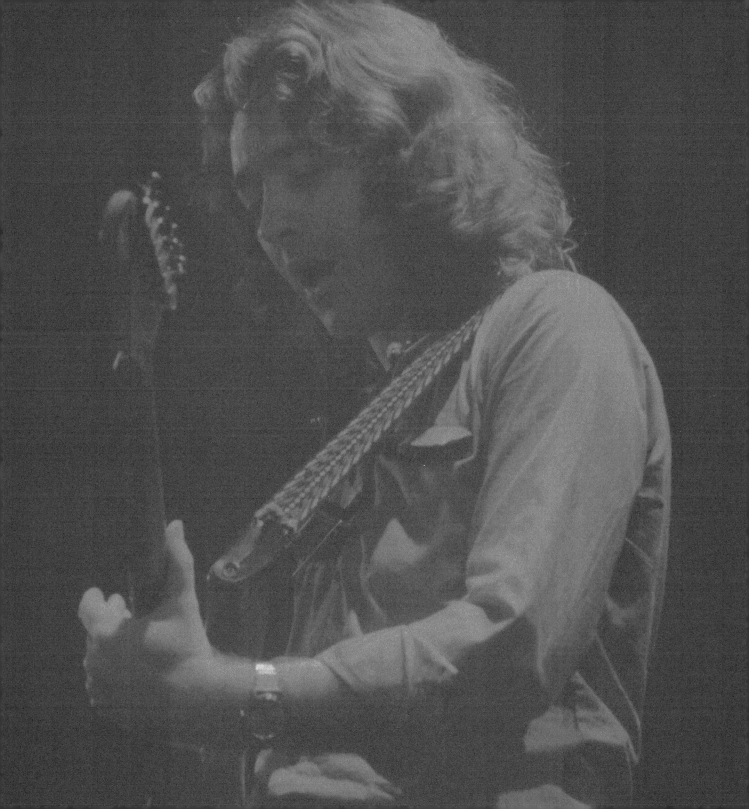

Nuala O'Connor *"There are almost no songs written directly about the Famine, any more than there are songs written about the Holocaust. There are so few songs written about the Famine because it is the unmentionable. It signified so much that was beyond everything; beyond language, beyond song, beyond music. It was like the epitome of negation of the soul and culture. The big book about culture in Ireland after the Famine is called The Great Silence and that's what it was. You have deep hurt, deep physic pain and all the rest of it which is either translated into schmaltzy stuff like that song about Ireland dropping from heaven or stereotypical, fantastical Galway Bay material or else very, very bitter songs like Skibereen."*

Bono (U2) *"You don't become an 'artist' unless you've got something missing somewhere. Blaise Pascal called it a God-shaped hole. Everyone's got one but some are blacker and wider than others. It's a feeling of being abandoned, cut adrift in space and time - sometimes following the loss of a loved one. You can never completely fill that hole - you can try with songs, family, faith and by living a full life... but when things are silent, you can still hear the hissing of what's missing."*

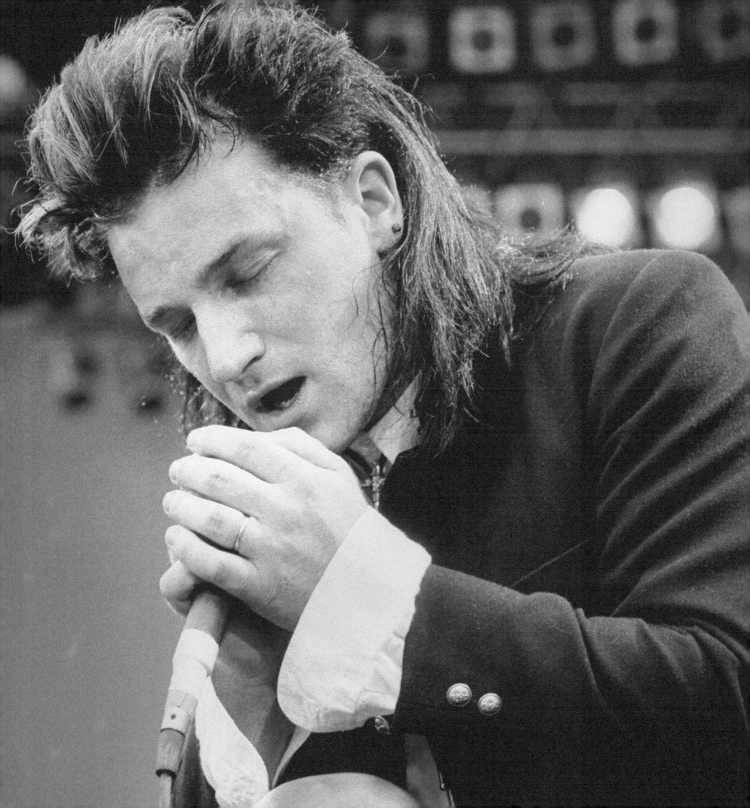

Tahe It Where You Find it
Van Morrison

Men saw the stars at the edge of the sea
They thought great thoughts about liberty
Poets wrote down words that did fit
Writers wrote books
Thinkers thought about it
Take it where you find it
Can't leave it alone
You will find a purpose
To carry it on
Mainly when you find it
Your heart will be strong
About it

Many's the road I have walked upon
Many's the hour between dusk and dawn
Many's the time
Many's the mile
I see it all now
Through the eyes of a child

Van Morrison "I just wanted to play blues – that's it. There was nothing here. There was a small group of people who were into blues and jazz. My father was one of them. That's how I discovered it… It was working-class music... In America, working-class was more like middle class. Here it was getting by on nothing. I related to the lyrics in Chicago blues and the stuff I heard by John Lee Hooker, not from their point of view – it was from my point of view. It was the same with Hank Williams. He was a voice. Muddy Waters was a voice. They were both blues singers to me. … And a lot of people who emigrated to the Southern states came from this area; here and Scotland. It's genetic."

"Someone once described me as a maverick and that's what I would say. I'm a maverick not by choice but by conviction."

"I didn't go along with their program... Because you don't want to be a fucking slave, right? They didn't want anybody who wasn't going to bend over for them. You're not complying – and they want you to comply. All this bullshit about rebels and all that crap – they're all establishment and complying all the time. All these so-called rebels, rock & roll bullshit – they're all conformists. Real rebels are people like Jerry Lee Lewis and Gene Vincent. They were the real rebels."

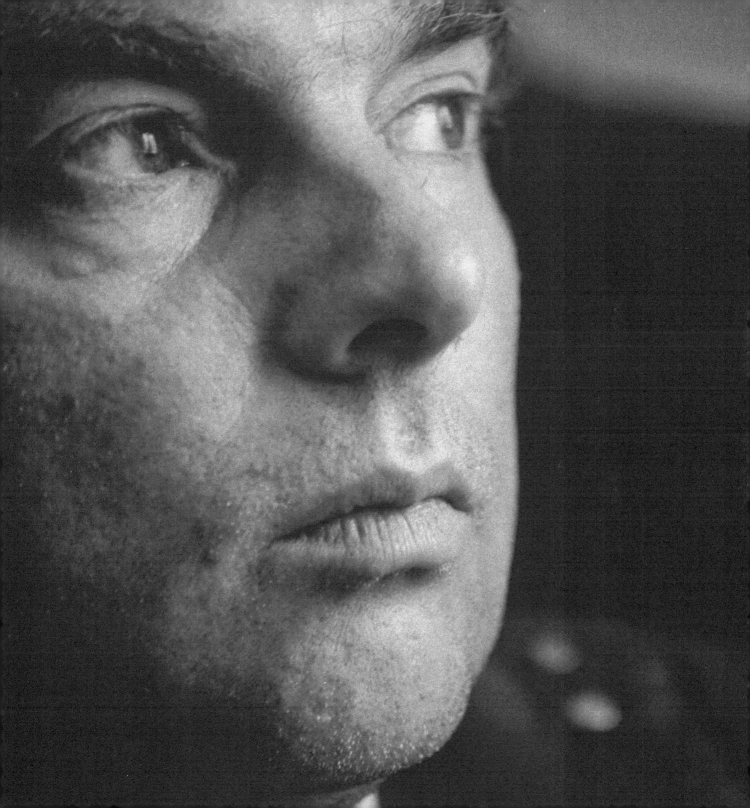

Whiskey in the Jar
traditional

As I was goin' over the Cork and Kerry mountains
I saw Captain Farrell and his money he was countin'
I first produced my pistol and then produced my rapier
I said, "Stand and deliver, or the devil he may take you!"

Musha ring dum a doo dam a da
Whack for my daddy-o
Whack for my daddy-o
There's whiskey in the jar-o

I took all of his money and it was a pretty penny
I took all of his money and I brought it home to Molly
She swore that she'd love me, never would she leave me
But the devil take that woman, for you know she tricked me easy

Musha ring dum a doo dam a da
Whack for my daddy-o
Whack for my daddy-o
There's whiskey in the jar-o

Being drunk and weary, I went to Molly's chamber
Takin' my Molly with me and I never knew the danger
For about six or maybe seven in walked Captain Farrell
I jumped up, fired off my pistols, and I shot him with both barrels

Musha ring dum a do dam a da
Whack for my daddy-o
Whack for my daddy-o
There's whiskey in the jar-o

Now some men like the fishin' and some men like the fowlin'
And some men like to hear the cannon ball a-roarin'
Me, I like sleepin', 'specially in my Molly's chamber
But here I am in prison, here I am with a ball and chain yeah

Musha ring dum a do dam a da
Whack for my daddy-o
Whack for my daddy-o
There's whiskey in the jar-o

Phil Lynott (Thin Lizzy) *"Once you're Irish and Catholic, you're always Irish and Catholic. I think it's in you. You can never disassociate yourself from it. You can acquire another accent, but it'll always be there in your head. The rules that were beaten into me at school are ingrained. I still know when I commit a mortal or a venial sin, y'know?"*

"I don't condone drugs, really, but I know why artists take drugs. They take them to experience, to go to the edge. Why do people climb mountains? To go to the edge. People always want to go to extremes. And if you go to the edge, you must be prepared to fall off."

"I'd like Ireland to become one nation, but then, we are. We seem to be all Irish when we're away from Ireland. When I'm in Ireland, I say I'm from Dublin, when I'm in Dublin, I say I'm from Crumlin. When I'm in Crumlin, I say I'm from Leighlin Road, and when I'm in Leighlin Road, I say I'm a Lynott."

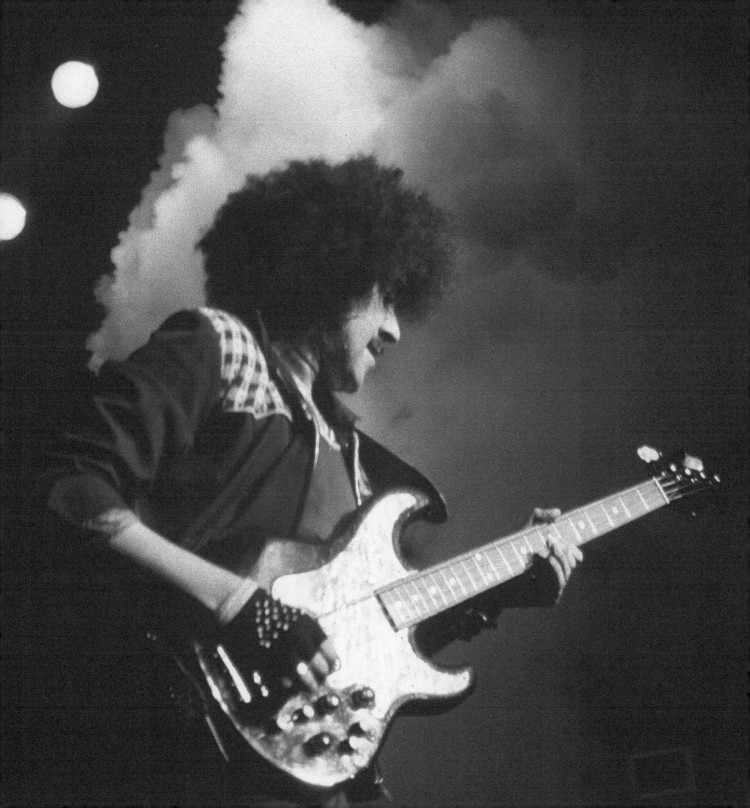

The Broad Majestic Shannon
Shane MacGowan

I sat for a while by the gap in the wall
Found a rusty tin can and an old hurley ball
Heard the cards being dealt, and the rosary called
And a fiddle playing Sean Dun na nGall
And the next time I see you we'll be down at the Greeks
There'll be whiskey on Sunday and tears on our cheeks
For it's stupid to laugh and it's useless to bawl
About a rusty tin can and an old hurley ball

Shane MacGowan (The Pogues) "My auntie Nora combined gambling on the Irish sweepstakes with teaching me my catechism for my first Holy Communion. She was a religious maniac. And she liked a drink and she chain-smoked. We used to pray on every horse. And we used to win again and again and again. My first horse came in at ten to one when I was five. And that is how I became a religious maniac and a total hedonist at the same time."

"Irish music is guts, balls and feet music... It's frenetic dance music, yeah? Or it's impossibly sad slow music... all sorts of subjects, from rebel songs to comical songs about sex. I don't think people realize how much innuendo there is. If you listen to a Dubliners record or a Clancey Brothers record the songs that aren't about drinking, or shooting the Brits, are gonna be about fucking. Like maids when they're young with an old man... Comical songs about getting hung... We've got a black sense of humor. Which is perfectly suited to New York. I think that's why we're understood in New York, much better than we are anywhere else in America."

7

"45 million Irish are in America when they should be in Ireland"

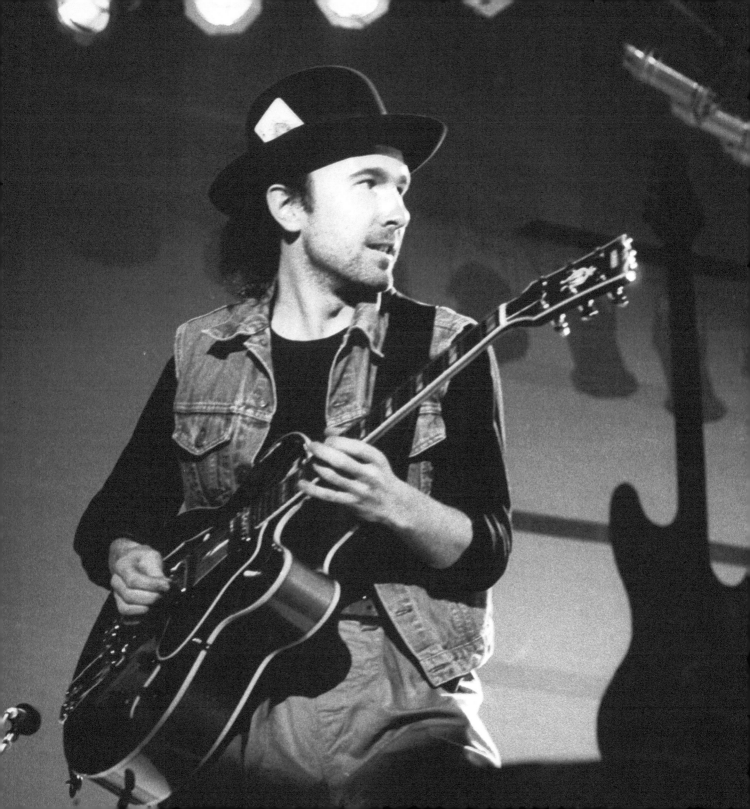

Max Hastings *"I am unusual among my own tribe in liking and respecting the Irish... As a historian, I recognize the monstrous injustice committed by the British government in 1921, when it partitioned Ireland before conceding independence to the South. This was done because a vociferous minority of a million Protestants, most of whose forebears were "planted" in Ulster by Oliver Cromwell's followers in the 17th century, fiercely resisted incorporation in an Irish state dominated by three million Roman Catholics... Supported by the Westminster Conservative Party, Ulstermen in 1912-14 had armed themselves to fight a civil war, rather than submit to rule from Dublin."*

"Two minorities still see virtue in keeping Ireland partitioned. The first is composed of a diminishing number of stubborn Protestant Unionists, who dominate their own community, but would become marginalised in a united Ireland. Meanwhile, some Southern politicians are privately fearful of the perils of absorbing several hundred thousand embittered 'Proddies'. Violence, so long an Irish tradition, remains very close beneath the country's skin, and every Irish politician knows it well."

Shane MacGowan (The Pogues) *"The greatest comrades of the Irish republican movement were the English working people, the miners and so on. And of course all that goes into what we did with The Pogues. It goes into what anyone anywhere does. We're entertainers first and foremost, yeah? And we'll sing rebel songs, love songs, and songs of Finbar Furey, who broke the mould at 17 years of age when he won a piping competition. The English people as a general rule, they were the ones that had the wool pulled over their eyes by the Unionists in England. The Unionists were holding onto an England that had crumbled all around them."*

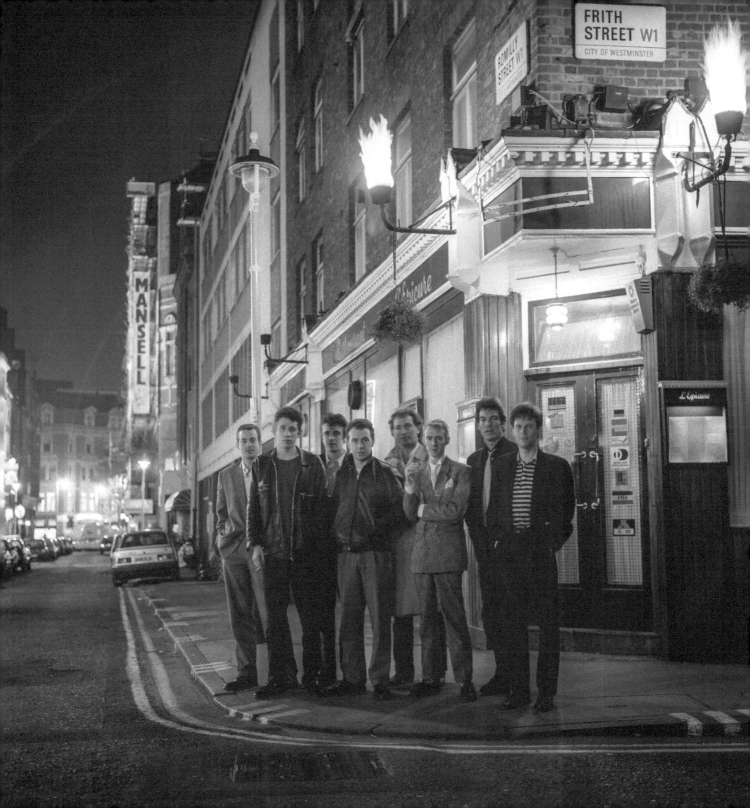

Clive Limpkin (The Battle of Bogside) *"The Ulster problem... is also a colonial war, fought between Protestant settlers, planted by the English conquerors centuries ago, and the native Catholics. The Catholics, it is said, are blacks who happen to have white faces. And like the poor whites of America who persecute the blacks, it is the poor Catholic who suffers at the hands of his Protestant counterpart."*

Allan Clarke (Ruefrex) "We're a passionate band and we sing angry songs. I can usually put up with things and I'll try to diffuse any situation, but if someones intent on giving me a hard time I'll show them no mercy. We were supporting Stiff Little Fingers down in the Mansion House in Dublin once and there was this apparently notorious gang going round the city calling themselves the Black Catholics. They had a reputation for going to gigs and disrupting them. There was a bunch of them at the front of the stage this particular night and they were shouting a lot of things at me like 'Go back to Belfast' and one thing or another. I had this big studded belt on which I took off. There were missiles coming up on the stage and everything. They kept it up and the next time I just followed it up and went ...CRACK!.... a big buckle round the fucken head. Yer man just sank like a bag of spuds."

10

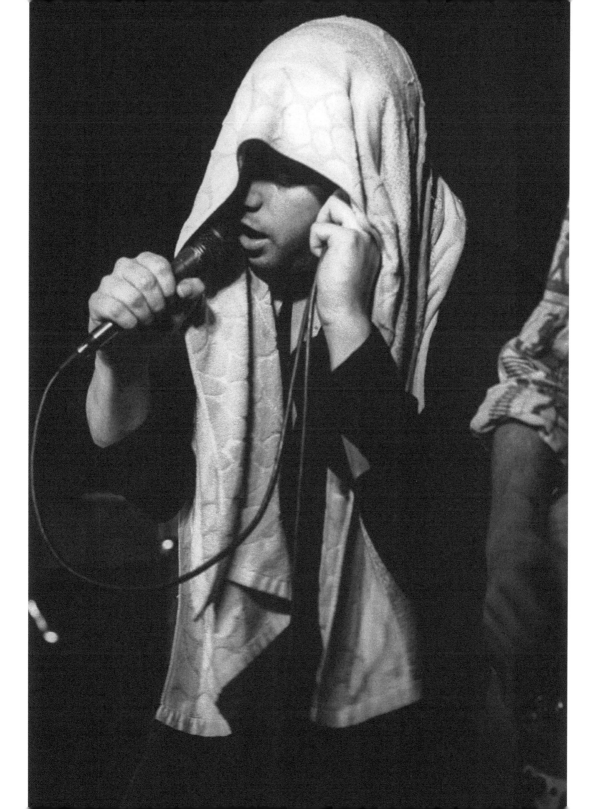

The Body of an American
Shane MacGowan

And fifteen minutes later
We had our first taste of whiskey
There was uncles giving lectures
On ancient Irish history
The men all started telling jokes
And the women they got frisky
By five o'clock in the evening
Every bastard there was piskey...

Johnny Depp "I've been very lucky to have a long history with Shane MacGowan. Before I met him I was fascinated by his language, his ability to make these incredibly moving, powerful songs yet at the same time kind of being on the heels of the devil."

Julian Temple "You only had to go to Pogues gigs to know Shane was a Republican Irishman. But I didn't quite understand how central the notion of re-inventing Irishness was to him. Getting rid of not just the twee aspects of how the music had become but also the whole "Oirish" kind of thing. He wanted a much more abrasive, young hip version of the tradition he saw himself coming from."

Glen Hansard "Growing up in Ballymun, if someone was passing around the tape, the tape would have The Dubliners and The Pogues. What made Shane's music different for me was that it was speaking to the broad diaspora. I remember seeing The Pogues in London in the late 80s in The Town and Country Club and there was an energy in the room that was really terrifying and frightening. It had something to do with being away from Ireland ... there was just this shock of passion and devotion."

11

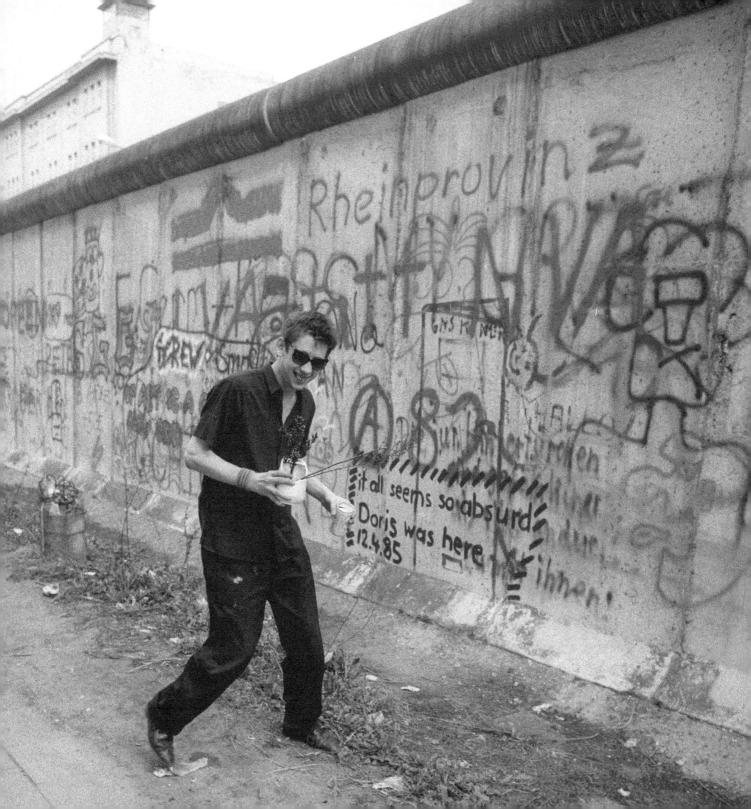

The Shamrock Shore
Traditional

All by those cursed tyrants we are forced for to obey
Some haughty landlords for to please
Our houses and our lands they'll seize
To put fifty farms into one and take us all away
Regardless of the widow's cries
The mother's tears and the orphan's sighs

'Lough Sheelin'
Traditional

But our good dreams were too good to last
The landlord came our home to blast
And he no mercy on us did show
As he turned us out in the blinding snow
No one dare open for us their door
Or else his vengeance would reach them sure;
My Eileen fainted in my arms and died
As the snow lay deep on the mountainside.

Bono *"The Irish have been coming to America for years, going back to the great famine when the Irish were on the run from starvation and a British government that couldn't care less. Right up to today, you know, there are more Irish immigrants here in America today than ever — some illegal, some legal. A lot of them are just running from high unemployment, some run from the Troubles in Northern Ireland, from the hatred of the H Blocks, torture. Others from wild acts of terrorism."*

"I've had enough of Irish Americans who haven't been back to their country in twenty or thirty years come up to me and talk about the resistance, the revolution back home; and the glory of the revolution, and the glory of dying for the revolution. Fuck the revolution! They don't talk about the glory of killing for the revolution. What's the glory of taking a man from his bed and gunning him down in front of his wife and his children? Where's the glory in that?"

"Poverty breeds despair. We know this. Despair breeds violence. We know this. In turbulent times, isn't it cheaper, and smarter, to make friends out of potential enemies than to defend yourself against them later?"

12

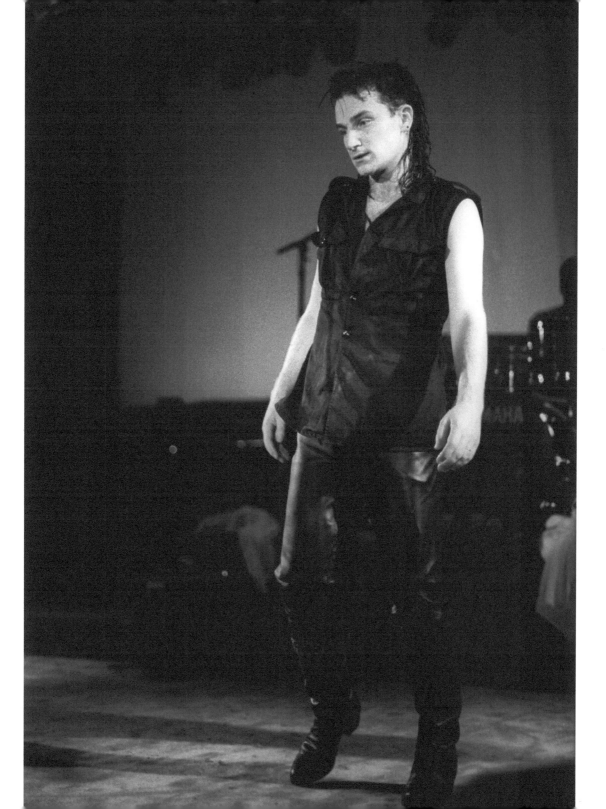

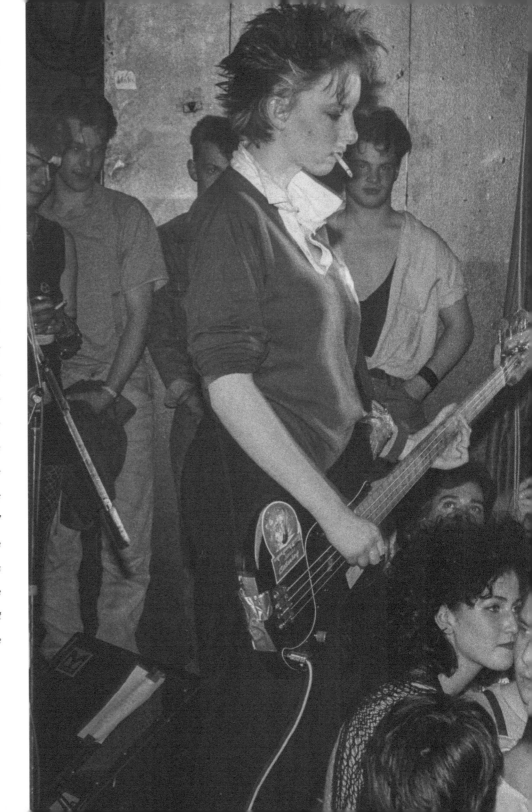

Berlin. Coincidentally, it was Hitler's birthday and some neo-nazis out to celebrate had ended up in the audience...

James Fearnley *"On a visceral level she was outraged, as one should justifiably be at Nazi salutes on Hitler's birthday at any gig, never mind ours..."*

Barry McIlheney *"Cait opted for the Redskin school of audience appeasement by offering to take the meatheads on... Philip Chevron delivered an inspired and perfectly pitched piece of verbals on how insulted he and his colleagues felt by the sieg-heiling antics of the noisy minority, and I just stood at the back and felt all sorts of little shivers go up my back when the proud strains of "The Band Played Waltzing Matilda" came cutting through the Berlin air like a knife. The Pogues left the stage to a tumultuous roar and it suddenly hit me after all this time that they may just be the greatest band in the whole wide world."*

The Men of Dublin
Traditional

They nailed their banners to the mast: the Orange, White and Green;
A nobler set of Irishmen the world has never seen.
They knew through sloth and idleness, a nation's soul was lost,
They rose to save dear Ireland's soul and counted not the cost.

They knew well that a thousand men — they did not number more
Could never break the tyrant's chain and drive him from our shore;
But this they knew — and knew it well — they would not die in vain,
Their blood would save our country's cause and give her life again.

Who was it led this noble band, and what has been their fate?
Was chivalry shown to them at last? No, worse than '98.
They fought 'gainst overwhelming odds, and held them well at bay,
Till Britain swore that she would make the innocent to pay.

Then woe betide the citizens who went abroad that night,
The soldiers lay in ambush, hid and shot them down at sight.
They shot the women and men, they shot the children, too;
The Defenders of Small Nations showed herself in colours true.

Then after the surrender, there began a tyrant's reign,
When young and old — the brave and true — all ruthlessly were slain.
Tom Clarke, the Brothers Pearse, and Daly, Colbert young and gay,
And Eamonn Ceannt and James Connolly were shot at dawn of day.

The same fate met Sean Heuston, McDonagh and MacBride,
But 'twas outside the G.P.O. the brave O'Rahilly died.
Mallin, Plunkett and McDermott fell before a firing squad,
Their blood, with brave O'Hanrahan's, for vengeance cries to God.

Great numbers, too, were sentenced then and sent across the sea;
The men and women, boys and girls, who strove to set us free.
Gold could not buy the ones who fought for Ireland through that week.
And they to make their sacrifice no purer cause could seek.

Enshrined are they forever more in every Irish heart;
God bless those men and women who played that noble part.
Who left their homes behind them, who left their kith and kin,
And rallied round their banner when the fighting did begin.

May their memory live forever! May our children bless the name
Of each one who fought for Ireland! May it ever be the same.
May your country still have hero's that are not afraid to die
On the battlefield or scaffold so our proud old flag may fly.

14

Tommy Sands *"The Fureys took Irish music out of the fridge and put a bit of heat under it."*

Finbar Furey *"I've been gigging all my life. I started travelling all over the west of Ireland with my father when I was 9 or 10. He often picked me up on a Friday after school and we'd go off for the weekend. He was the last of the wandering musicians, he'd hitchhike down to Clare and you wouldn't see him for a week, and he'd come back with a few bob for me Ma. He'd pick up tunes wherever he went. He wrote a book for fiddle and pipes with over 200 tunes in it, hand written."*

"I was always a rebel in music. I always said that music has to move forward...you can't leave it to go stale like a block of cheese."

"When you look at the world at the moment...we gotta look at each other and say 'come on, we're the human race, we all come from the same seed'. This planet is all we have, there's nothing outside of this. We're travelling at 67,000 miles an hour through space and there's fuck all else out there, and even if there was it's too far away for us to get to. People have to understand how important this place is. I'm green-minded, but I'm very much interested in moving forwards without destroying everything. It's like cutting down the rainforest, you can't replace that, it took millions of years to develop."

"I'm just a musician... maybe we might stir them up enough to do something about it. I'm not a politician, and I never would be, but I'm not blind to what's going on in the country."

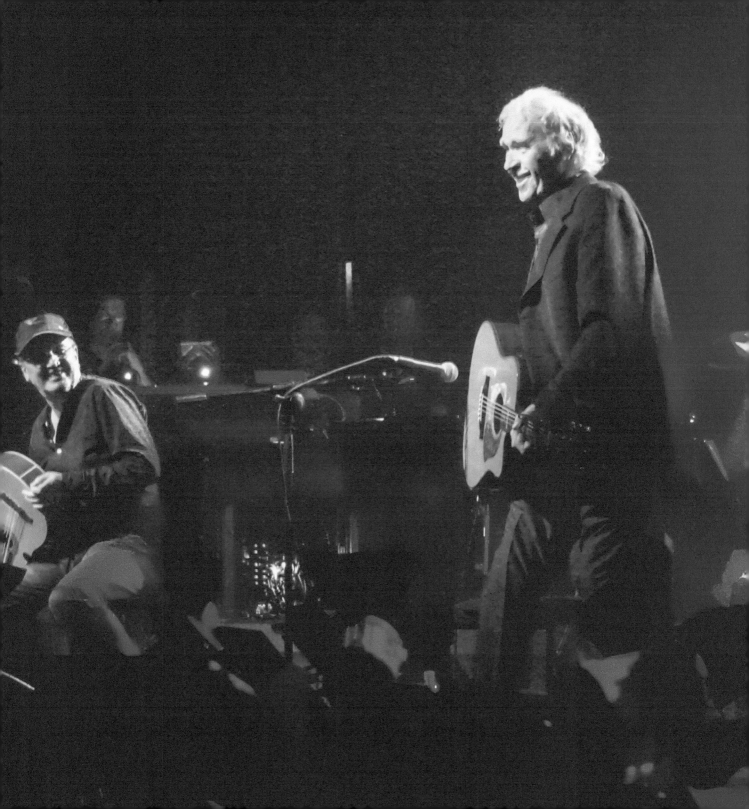

Bob Geldof (Boomtown Rats) "We're looking at the singular condition of poverty. All the other individual problems spring from that condition... doesn't matter if it's death, aid, trade, AIDS, famine, instability, governance, corruption or war. All of that is poverty. Our problem is that everybody tries to heal each of the individual aspects of poverty, not poverty itself."

"I'm the only person who got a knighthood for saying fuck."

"Bono as we all know, is in love with the world, he's enamoured by it. I'm enraged by it. He wants to give the world a great big hug, I want to punch its lights out."

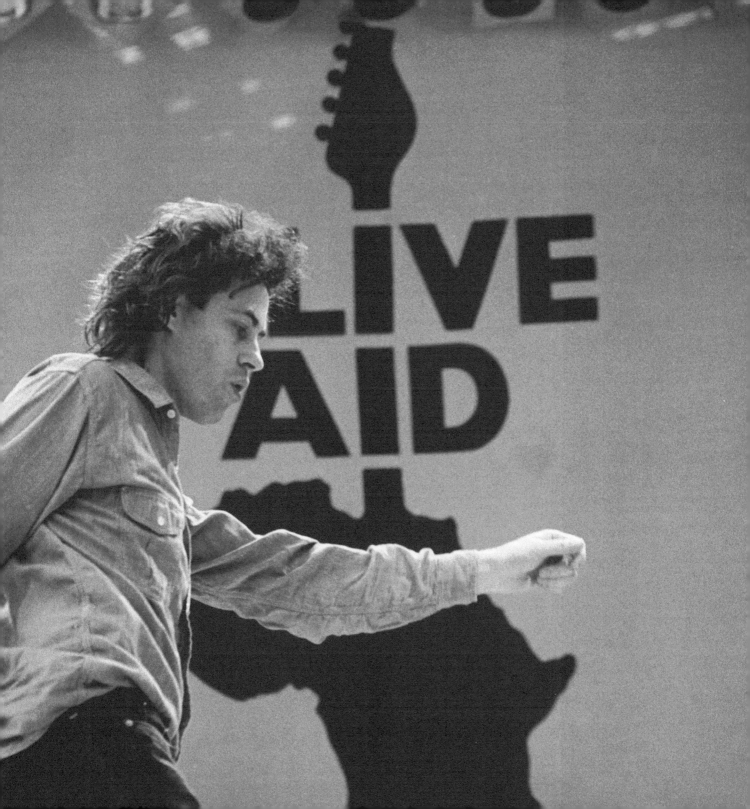

Walking home three parts pissed
I stumbled and fell in the morning mist
I fell and rolled in the hungry grass
That tells the tale of a terrible past
I screamed and ran and dreamt I fell
Down in the depths of a freezing hell
Four million people starved to death
Could smell the curse on their dying breath

Shane MacGowan *"I have no self-destructive impulses whatsoever. Anyone with a death wish should be dead. It's not that difficult to do. If I really wanted to die, I'd be dead already."*

"The Pogues would never have existed if I hadn't been Irish. Ireland means everything to me. I always felt guilty because I didn't lay down my life for Ireland, I didn't join up. Not that I would have helped the situation, probably. But I felt ashamed that I didn't have the guts to join the IRA. And the Pogues was my way of overcoming that guilt. And looking back on it, I think maybe I made the right decision."

16

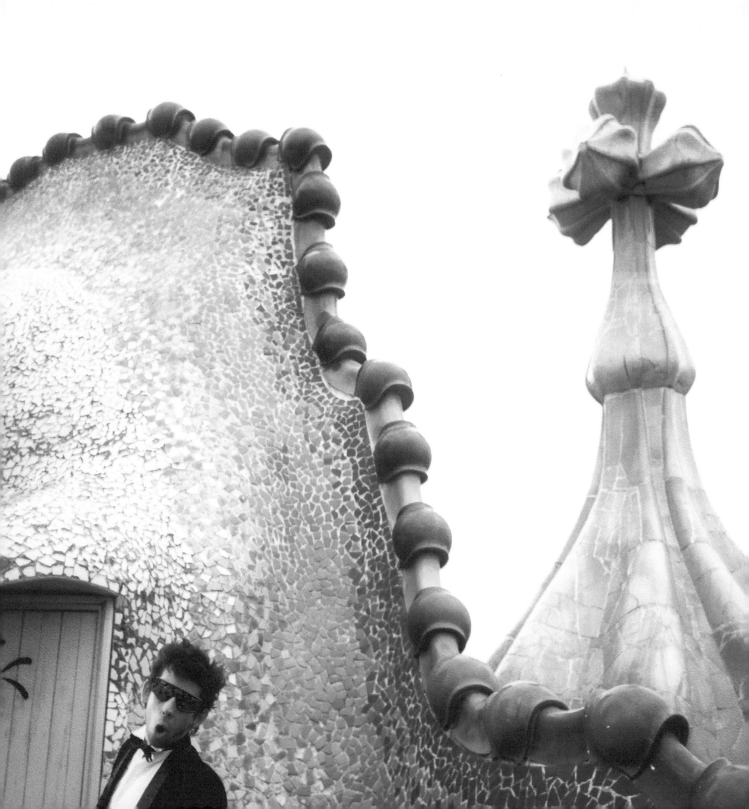

Thousands are Sailing
Philip Chevron

The island it is silent now
But the ghosts still haunt the waves
And the torch lights up a famished man
Who fortune could not save
Did you work upon the railroad?
Did you rid the streets of crime?
Were your dollars from the White House?
Were they from the Five-and-Dime?

George Petrie in the introduction to an 1855 volume on The Ancient Music of Ireland:

"The green pastoral plains, the fruitful valleys, as well as the wild hillsides and the dreary bogs, has equally ceased to be animate with human life. The 'land of song' was no longer tuneful; or if a human sound met the traveller's ear, it was only that of the feeble and despairing wail for the dead. This awful unwonted silence, which during the famine and subsequent years, almost everywhere prevailed, struck more fearfully on their imaginations, as many Irish gentlemen informed me, and gave them a deeper feeling of the desolation with which the country had been visited, than other circumstances which had forced itself upon their attention."

Philip Chevron "What makes Shane MacGowan's songwriting as good as it is, is, partly - I don't say entirely - that he has respect for the tradition of the Irish ballad. He's carried on that tradition."

17

"Shane's genius was that he was able to see that punk rock and Irish traditional music shared a sense of spiritual rebellion. He thought of that. He saw they shared the same roots."

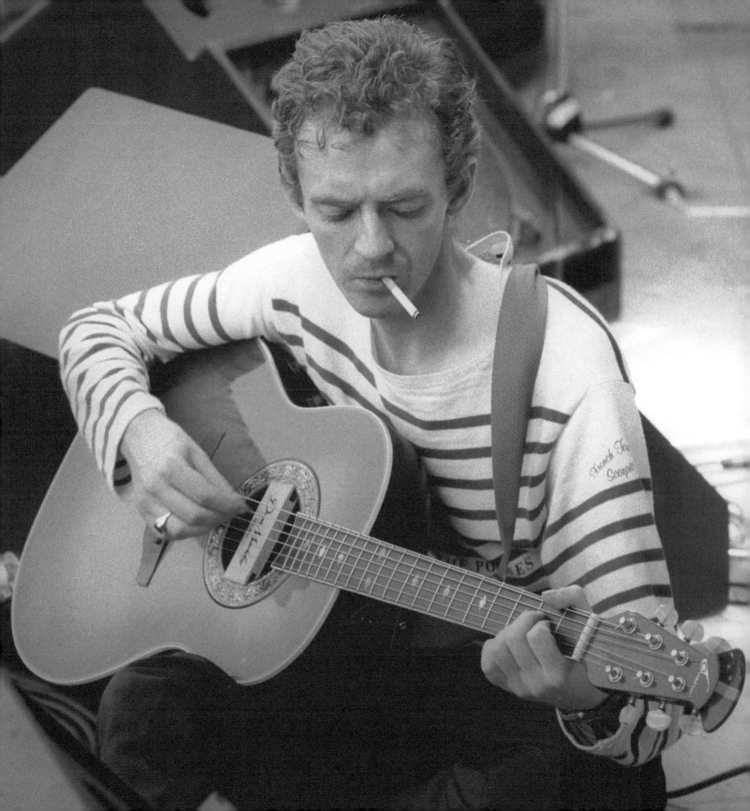

The Glen of Aherlow
Charles Joseph Kickham

My father died, I closed his eyes outside our cabin door;
The landlord and the sheriff too were there the day before.
And then my loving mother, and sisters three also,
Were forced to go with broken hearts from the Glen of Aherlow.

1871 letter from Dr. Thomas Nulty, Bishop of Meath, to the
clergy of his diocese on the evictions being enforced across
Ireland by British landlords:

*"Seven hundred human beings were driven from their
homes in one day and set adrift on the world, to gratify the
caprice of one who, before God and man, probably deserved
less consideration than the last and least of them. The
horrid scenes I then witnessed, I must remember all my life
long. The wailing of women – the screams, the terror, the
consternation of children – the speechless agony of honest
industrious men – wrung tears of grief from all who saw
them. I saw officers and men of a large police force, who
were obliged to attend on the occasion, cry like children
at beholding the cruel sufferings of the very people whom
they would be obliged to butcher had they offered the least
resistance. The landed proprietors in a circle all around
– and for many miles in every direction – warned their
tenantry, with threats of their direct vengeance, against the
humanity of extending to any of them the hospitality of a
single night's shelter... and in little more than three years,
nearly a fourth of them lay quietly in their graves."*

Sinéad O'Connor *"The important thing about "brave"
is, it doesn't mean you're not terrified."*

*"Forgiveness is the most important thing. We all have
to forgive what was done to us - the Irish people have
to forgive. The African people. The Jewish people. We
all have to forgive and understand the only way to stop
the cycle of hate and abuse is not to allow yourself to get
caught in it."*

*"I don't do anything in order to cause trouble. It just so
happens that what I do naturally causes trouble. I'm
proud to be a troublemaker."*

18

*"We have a tradition of passing our history orally and
singing a lot of it and writing songs about it and there's
kind of a calling in Irish voices when they're singing..."*

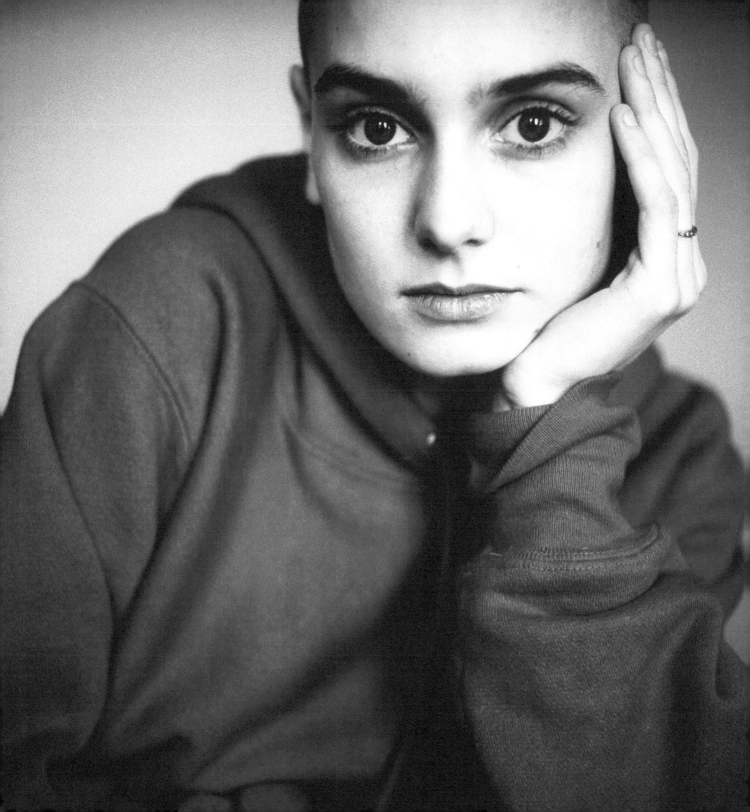

Skibereen

traditional

Father, dear, I often hear you speak of Erin's Isle.
It seems so bright and beautiful, so rich and rare the soil.
You say it is a bounteous land wherein a prince might dwell.
Then why did you abandon it? The reason to me tell.

It's well I do remember the year of forty-eight,
When we arose with Erin's boys to fight against our fate;
I was hunted through the mountains as a traitor to the Queen,
And that's another reason that I left Old Skibbereen.

Damien Dempsey "There were always parties at home where everyone would sing, and I begged to stay up to listen. Then I heard Thin Lizzy's Whiskey in the Jar when I was 12, and I just wanted to get a guitar and grow my hair.... In my teens... I was going through a bit of a phase, drinking a lot and doing E tablets and getting into street fighting and getting depressed. Then I'd listen to Marley and it lifted me out of it."

"Reggae comes from a brutal colonial background, and they've turned that around into something beautiful and positive. We have a similar history and our music has these great uplifting tunes and ballads. It's rebel music: a rebellion against the powers that be."

"I'd like to try and do the same for kids, that my music would give them a bit of hope and strength. I was on the dole for a few years and I used to go into the library in Donaghmede... I'd go in and read about Irish history, because I wasn't really taught much about it in school, so I felt I had to educate myself... that's where I learnt about the importance of the seanchai, the Gaelic storytellers."

19

"The true history of a place is written in song.... the history books are written by people who have an agenda... If you want to know what was going on, you listen to the folk songs and the ballads."

John Donoghue "In 1652 the English Commonwealth appointed William Petty to assess the future value of expropriated Irish land and labour. Petty collected his findings and analysed them in '*A Political Anatomy of Ireland*'. The 1692 tract helped lay the foundation for a new field of knowledge—political economy, which Petty called 'political arithmetic'—that guided the rise of global capitalism. His research in Ireland and his wider knowledge of the Atlantic economy led him to conclude that, rather than destroying the Irish, English interests would be best served in the colonies by 'enslaving them like negroes':

'You value the people who have been destroyed in Ireland as slaves and negroes are usually rated, viz, at about 15 one with another; men being sold for 25, children for 5 … Why should not insolvent thieves be punished with slavery rather than death. So as being slaves they may be forced to as much labour, and as cheap fare, as nature will endure, and thereby become as two men added to the commonwealth, and not as one taken away from it.'

The Cromwellian regime envisioned enslaving Irish and 'negroes' in parallel fashion. In the British Caribbean, white indentured servants made up the majority of the unfree plantation workforce until the late 1650s. The same held true in the Chesapeake until about 1690."

"Cromwell himself oversaw the first wave of colonial transportation to the Caribbean. Writing to parliament after leading the slaughter at Drogheda in September 1649, the general reported that the *'officers were knocked on the head, and every tenth man of the soldiers killed, and the rest shipped for the Barbadoes'*. Cromwell argued that massacre and transportation were benevolent forms of terrorism, as they would frighten the Irish into submission and thus *'prevent the effusion of blood for the future'*."

Richard Ligon (a planter on Barbados from 1647 to 1650) wrote that planters bought 'servants' in the same way they purchased slaves from Africa, on the same ships that brought them to the island. Both servants and slaves were summoned to the fields early in the morning, often by bells, and they both were worked into the evening. Both were subject to 'severe overseers' who beat them during their labours. *'I have seen such cruelty there done to servants as I did not think one Christian could have done to another'*.

Glen Hansard "Everything about singing, I learned from busking. Everything I learned about songwriting, I learned from busking. Busking, you learn people, you learn about reading people. You learn about reading the atmosphere of the street. If you stand still in any city long enough, you see everyone pass you by. It's almost like you get to know personality types, just by watching people walk past. You get a sense for things."

"We saw too much beauty to be cynical, felt too much joy to be dismissive, climbed too many mountains to be quitters, kissed too many girls to be deceivers, saw too many sunrises not to be believers, broke too many strings to be pro's and gave too much love to be concerned where it goes."

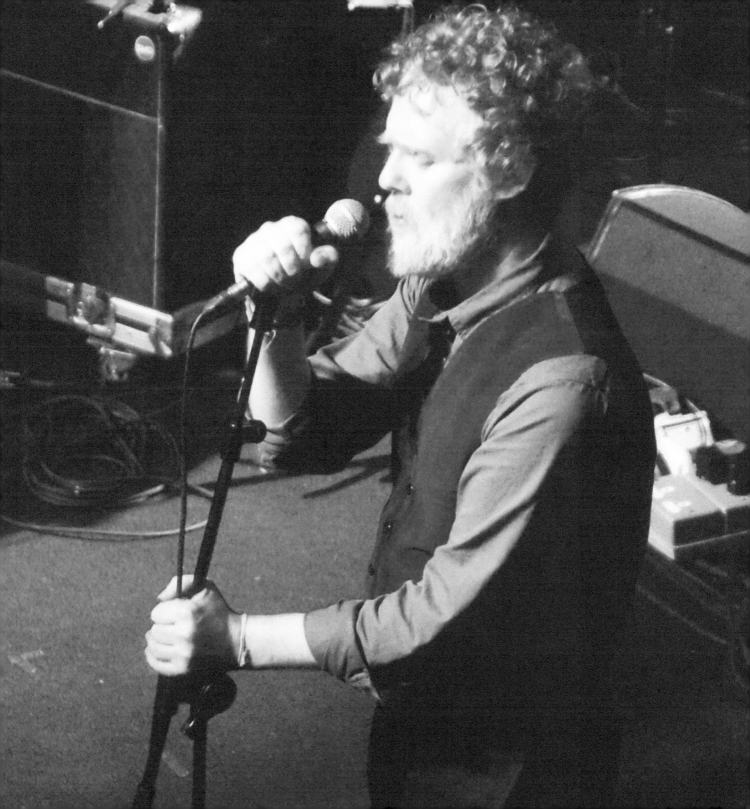

Grace
Sean & Frank O'Meara

As we gather in the chapel here in old Kilmainham Jail
I think about the last few weeks: Oh will they say we've failed
From our schooldays they have told us we must yearn for liberty
Yet all I want in this dark place is to have you here with me.

Oh Grace, hold me in your arms, let this moment linger
They take me out at dawn and I will die
With all my love I place this wedding ring on your finger
There won't be time to share our love for we must say goodbye

Now I know it's hard for you, my love, to ever understand
The love I bear for these brave men, my love for this dear land
But when Padraic called me to his side down in the G.P.O.
I had to leave my own sick bed, to him I had to go

Now as the dawn is breaking, my heart is breaking too
On this May morn as I walk out my thoughts will be of you
And I'll write some words upon the walls so everyone will know
I loved so much that I could see his blood upon the rose.

Cait O'Riordan "It was very difficult growing up London-Irish in the 1970s, having this funny name and parents who had this funny accent, with bombs going off . . ."

Cait O'Riorden "Landmarks in my life used to get marked out by records. Like, I remember the first record I bought with my own pocket money, which was an Elvis Presley single in a second hand shop near where I lived."

"When I started my first grownup job, even though I was 14 or 15, my first wage packet from the waitressing gig I used to do after school, I went and bought Boy by U2 at the record store."

21

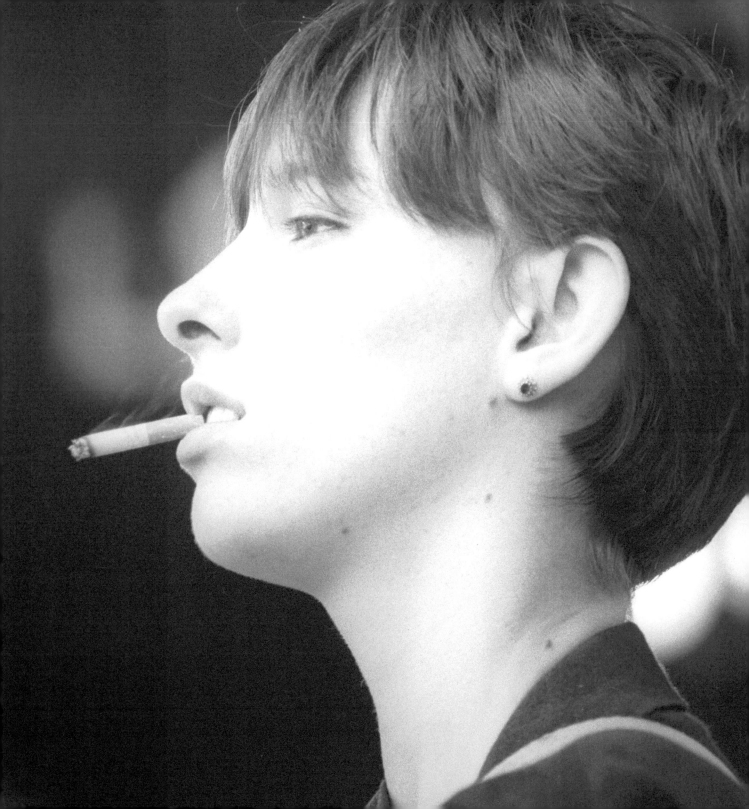

The Dunes
Shane MacGowan

When I watched at the age of four
in Eighteen Forty Seven
the mounds they built upon the shore.
They seemed to point to heaven
they seemed to point to heaven.

But the wind and the rain they have worked away.
Now the dunes are uneven
and the children kick the sand around
and the bones they are revealed then
and the bones they are revealed then.

They stole our grain as we died in pain
to put upon their tables.
The dying covered the dead with sand
and danced while they were able

While the fiddler played we drank poitin
and ate the last of the berries.
Then knelt and said the rosary
round the mounds of dead we'd buried

Paul Simon *"I tip my hat to Shane MacGowan, whose voice reveals something deep and beautiful about the Irish soul."*

Liam Neeson *"He took aspects of Irish culture and Irish music and kicked it up the arse, with a great sense of pride and joy and rebelliousness, and sent it out into the world. And it was fecking great! It stopped us all moping into our pints or Baileys Irish Cream and took pride in ourselves."*

Tom Vaughn-Lawlor *"I moved to London in my early 20s and it was often quite a lonely time to begin with, and where Shane's writing and performing spoke to the punk in me as a teenager, he was now speaking to me as young Irishman in London trying to find his way. He has that special gift of making it feel he's speaking to and for your soul, and your soul alone, and it's one of the many reasons he's a truly great artist and an amazing man."*

Bobby Gillespie *"He has vast empathy for other human beings. Their excesses, their joys, their feelings and struggles. He has a poet's eye for seeing things in everyday life that most of us don't see. Punk, poet, Irishman, outsider – rock on Shane."*

22

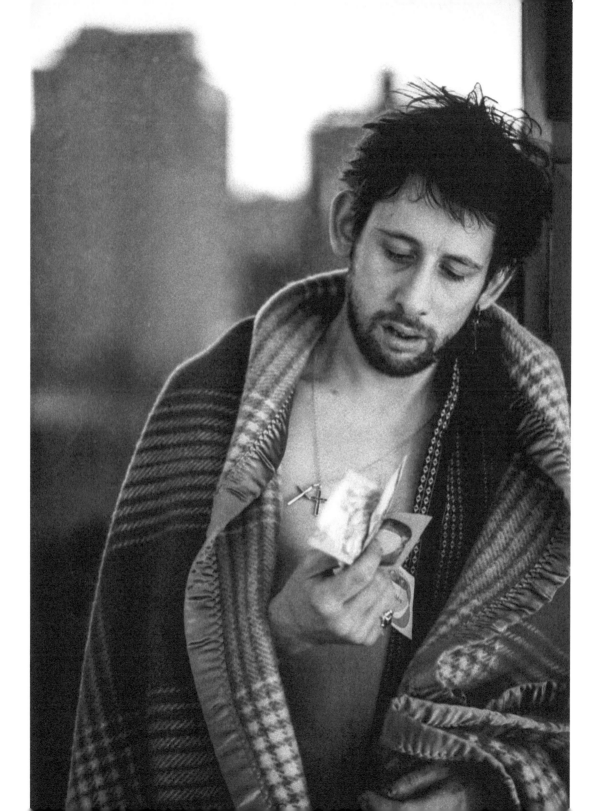

I'm a Man You Don't Meet Every Day
traditional

Oh, my name is Jock Stewart
I'm a canny young man
And a roving young fellow I have been.
So be easy and free,
When you're drinking with me
I'm a man you don't meet every day

I have acres of land
I have men of command
I have always a shilling to spend
So be easy and free,
When you're drinking with me
I'm a man you don't meet every day

So come fill up your glasses with brandy and wine
Whatever it costs, I will pay
So be easy and free,
When you're drinking with me
I'm a man you don't meet every day

Oh, I took out my dog,
and him I did shoot
All down in the County Kildare
So be easy and free
When you're drinking with me
I'm a man you don't meet every day

So come fill up your glasses with brandy and wine
Whatever it costs, I will pay
So be easy and free,
When you're drinking with me
I'm a man you don't meet every day

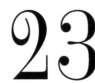

Cait O'Riordan "It's that thing of carrying a culture inside you, but being surrounded by a different culture, a much different culture that is trying to crush out your own culture. When you're put under that pressure, you either crumble or you get stronger in your own culture, which very much happened with the London Irish under Thatcher."

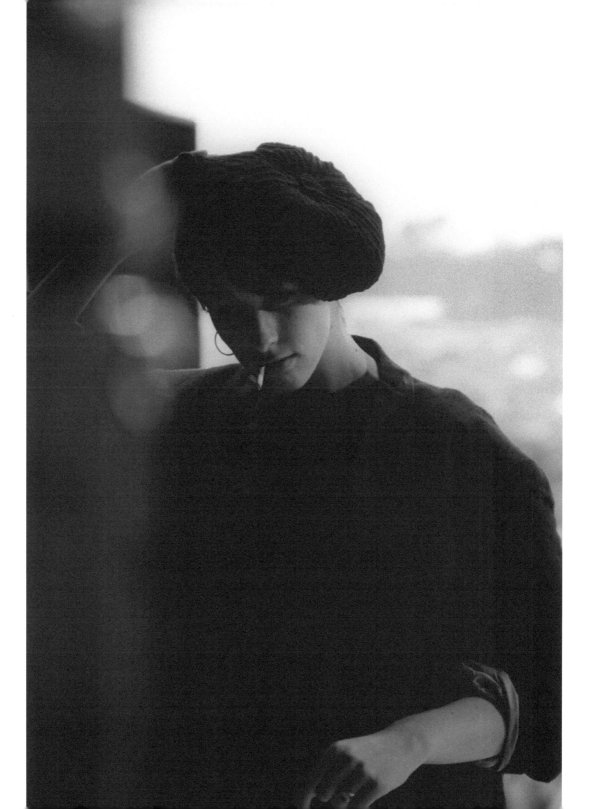

This is a Rebel Song
Sinéad O'Connor

I love you my hard Englishman
Your rage is like a fist in my womb
Can't you forgive what you think I've done
And love me - I'm your woman...

... Ah, please talk to me Englishman
What good will shutting me out get done
Meanwhile crazies are killing our sons
Oh listen - Englishman
I've honoured you - hard Englishman
Now I am calling your heart to my own
Oh let glorious love be done
Be truthful - Englishman

24

Sinéad O'Connor *"When I was 18 I was in love with a Provo and I wanted him to love me and said all that shit I have since gone out of my way to retract. But in relation to This IS A Rebel Song, I wrote it in order to generate debate, because artists should say what isn't allowed to be said. There is this war in this country we're not allowed to talk about, because of the existence of terrorism, lest we be associated with one side or the other.*

That is exactly what has happened to me as a result of this song. In fact, it's a love song about a relationship I had with a man and it comments on how this is like the relationship between Ireland and England. But even though it calls for England to give Ireland back and allow all the people who live in this land to govern it, in that I include loyalists who, I believe, should bring their political and religious influence into a United Ireland. Yet certain Unionists think I'm suggesting they should give up their identity. I'm not. This song calls for a marriage, not divorce. And it's a 'rebel' song only because it rebels against this fear we have of talking about the situation."

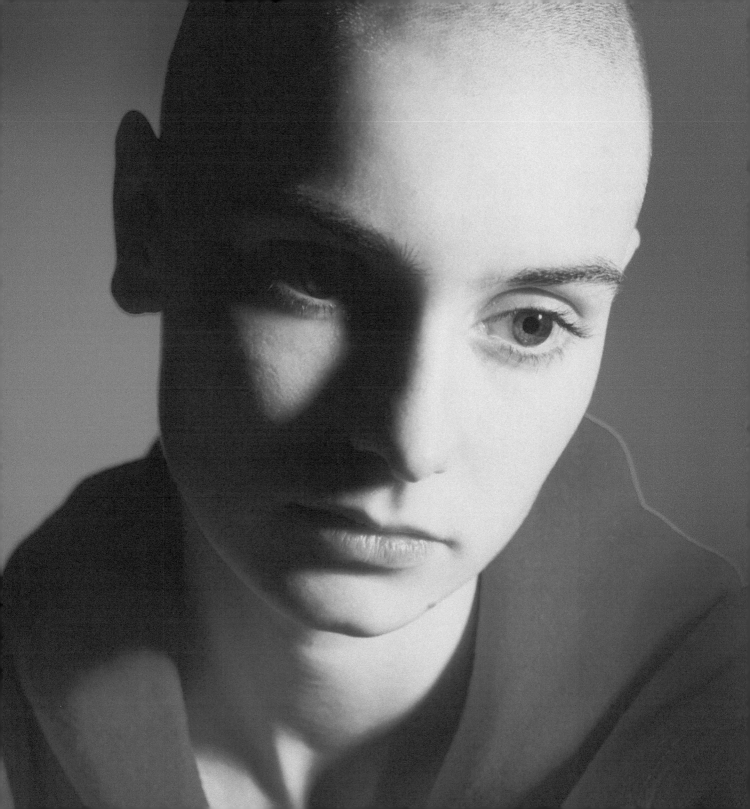

Fairytale of New York
Shane MacGowan

They've got cars big as bars
They've got rivers of gold
But the wind goes right through you;
It's no place for the old
When you first took my hand
On a cold Christmas Eve
You promised me Broadway
Was waiting for me

25

Philip Chevron "The Pogues' audience made that song their own and when Shane sings the line, 'I could have been someone', Kirsty responds in harmony with, 'well so could anyone'. That became the big hook in the song because when we performed it live, four or five thousand people would sing along with her."

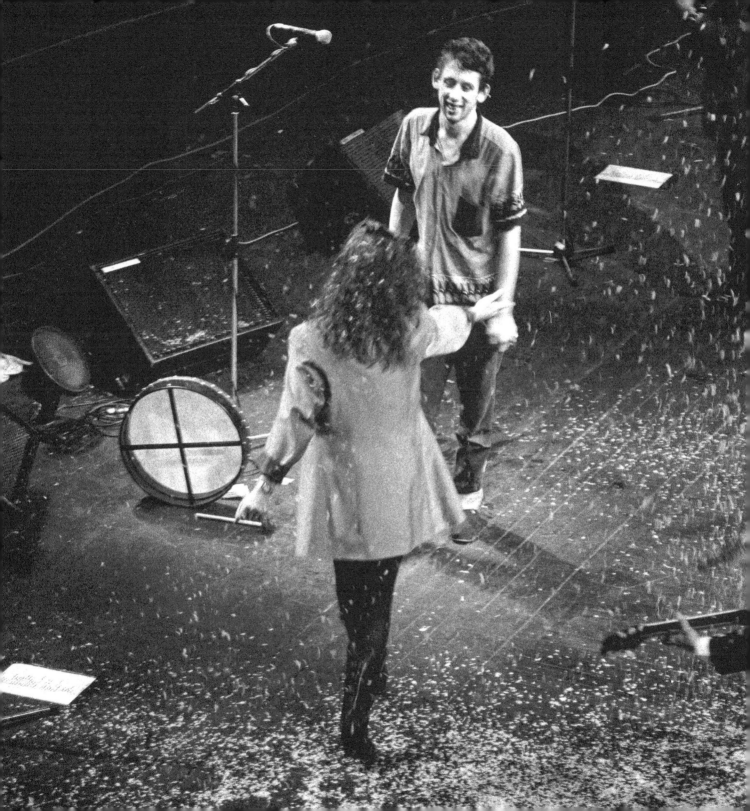

The Wild Colonial Boy
Allan Clarke/Paul Burgess

Well I'm the Emerald Isle's own son,
I was born on stateside, Wisconsin.
And your troubles sound like Hollywood,
they sound real good to me.

The rush to be Irish now is on,
the queue is standing ten miles long,
and would-be green men stand in line,
to swap their stories tall.

Well I have traced my past right back,
I've even checked and double checked,
and I'm as sure as ever now
that I'm a leprechaun.

And I know that if I get my chance,
that I can jig, and reel, and dance,
cuz in between the killing
that's what all us Irish do.

*Allan Clarke (Ruefrex) "We don't apologise for who
we are - working-class Belfast Prods - but our message
has always been anti-sectarian. Unlike other punk
bands from the late 1970s that put across the same
anti-sectarian message, Ruefrex put its money where
its mouth was. We were the only band from the
era who played gigs to raise money for integrated
education. We were also the only ones that broke out of
the Harp Bar/Pound Punk ghetto in downtown Belfast.
Although we all came from loyalist north Belfast, we
played gigs in republican areas in the west like Turf
Lodge and Twinbrook."*

*Paul Burgess "There is still a lot I need to get off
my chest, especially about the present alienation of
Protestant working-class loyalists. They are being left
behind in the peace process and the recent violence on
the Shankill Road proves that this is a very dangerous
thing. There's probably more of a need now to give
that community an articulate voice through music
than ever before, because they feel no one is listening
to them. And I want to get across like before that this
voice doesn't have to be triumphalist or sectarian, that
it has a place in the world."*

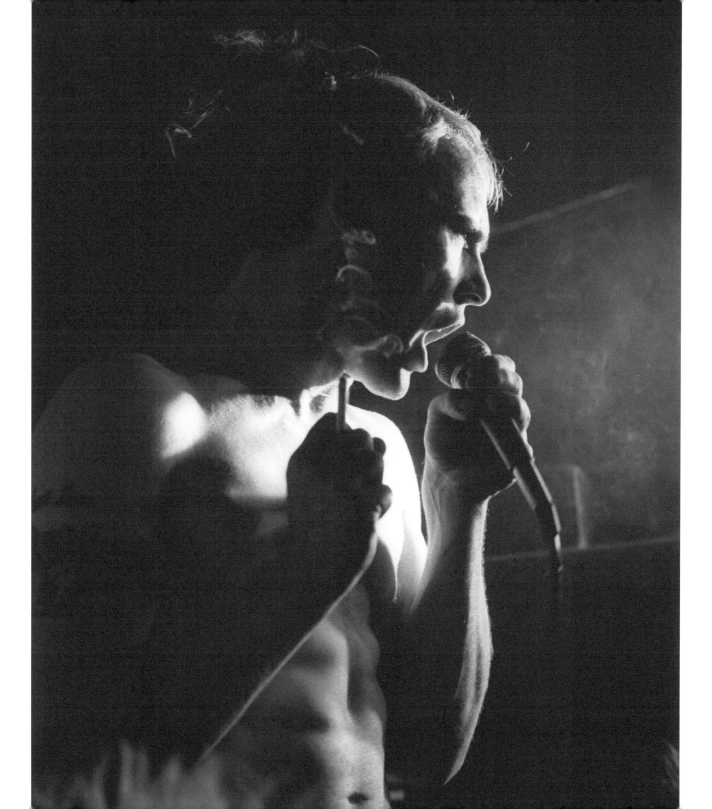

The Minstrel Boy
Thomas Moore

The Minstrel-Boy to the war is gone,
In the ranks of death you'll find him;
His father's sword he has girded on,
And his wild harp slung behind him.
"Land of song!" said the warrior-bard,
"Tho' all the world betrays thee,
One sword, at least, thy rights shall guard,
One faithful harp shall praise thee!"

The Minstrel fell!—but the foeman's chain
Could not bring that proud soul under;
The harp he lov'd ne'er spoke again,
For he tore its chords asunder;
And said, "No chains shall sully thee,
Thou soul of love and bravery!
Thy songs were made for the pure and free,
They shall never sound in slavery.

Frank Kearns (Cactus World News) "It all started back in April of 1984 when I was playing in a band in London. It wasn't going anywhere so, after a lot of thought, I decided to go back to Dublin and start a band with some aggression - a vehicle for pushing melody to its extreme."

"Music occupied a different place in people's heads back then. It was seen as vital. There wasn't talk of us being 'content providers' or whatever bullshit they are calling creative musicians now. All of us were passionate about our music and still are, so it's alien for me to see music as anything other than an essential essence of life."

27

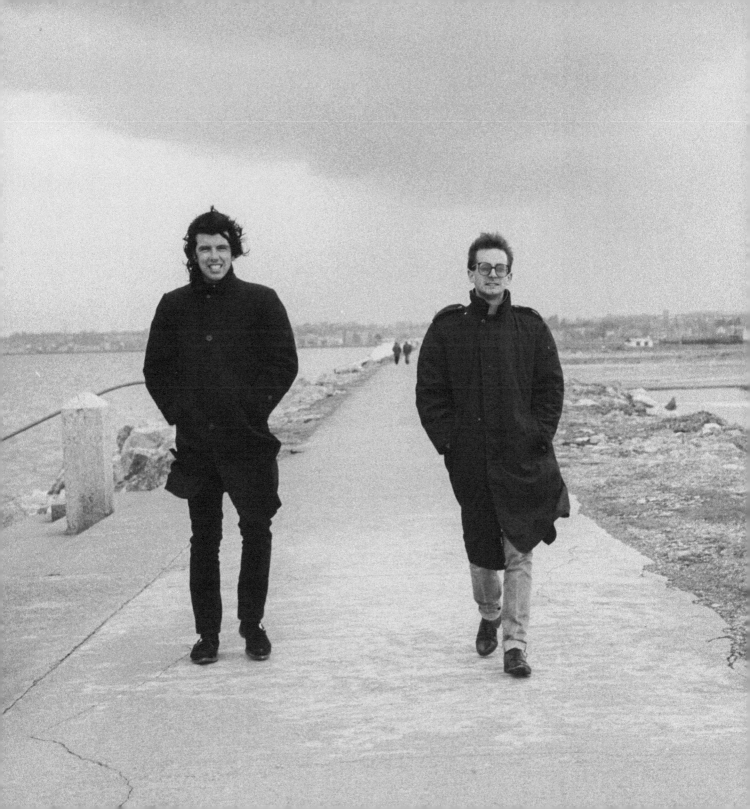

Sydney Smith *"The moment the very name of Ireland is mentioned, the English seem to bid adieu to common feeling, common prudence and common sense."*

Fergal Sharkey (Undertones) "One of the reasons we keep going back to Derry is that it keeps us down to earth and drags us back to normality. If we stayed in London, we'd just become a part of it all and change drastically, just like every other band seems to do when they leave and move over to England."

"If it's wrong, change it. This came from my parents. They were very active politically in Northern Ireland in the 1960s and charged up my interest in civil rights. They always told me, 'If there is an injustice in the world that needs changing, change it.' And they led by example."

28

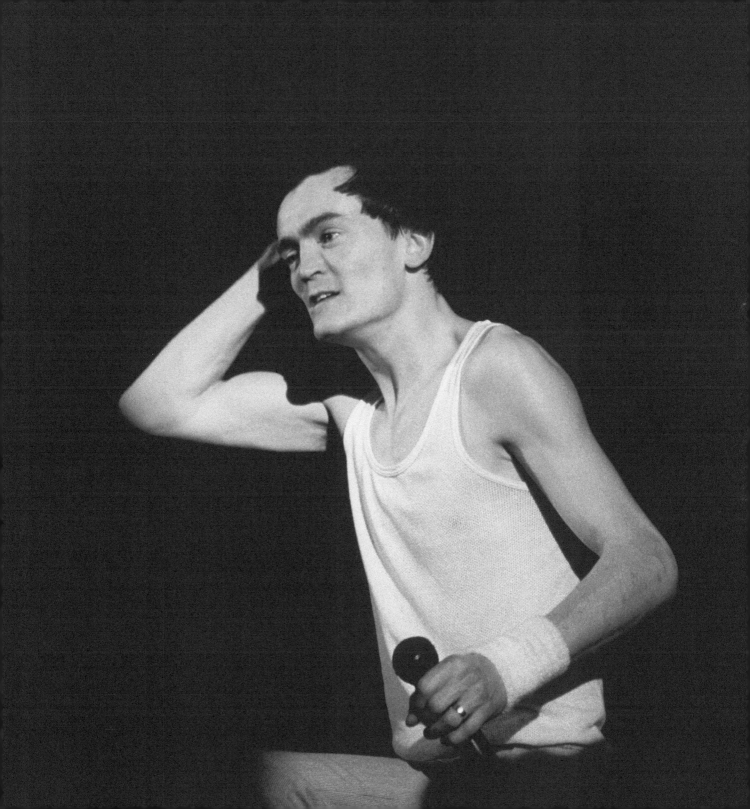

Boys of the Old Brigade
traditional

Where are the lads who stood with me
When history was made?
Oh, gra machreee I long to see
The Boys of the Old Brigade.

"Oh father, why are you so sad,
on this bright Easter morn?
When Irishmen are proud and glad
Of the land where they were born."
"Oh, son, I see in mem'ries view
A far-off distant day,
When, being just a boy like you,
I joined the I.R.A

In hills and farms the call to arms
Was heard by one and all,
And from the glens came brave young men
To answer Ireland's call.
'Twas long ago we faced the foe,
The old brigade and me,
But by my side my God and I
So Ireland might be free.

And now, my boy, I've told you why
On Easter morn I sigh
For I recall my comrades all
From dark old days gone by,
I think of men who fought in vain
With rifle and grenade
May Heaven keep the men who sleep
From the ranks of the old brigade.

Steve Mack (That Petrol Emotion) "They had civil rights marches in Derry and they got smashed and shot at... People got angry and they chose to fight fire with fire...."

"We were always flabbergasted by how little people knew about what was going on in Northern Ireland, especially when we went to America. We were kicking against the pricks a bit with what we were doing."

Raymond Gorman "Some people were saying we were the musical wing of the IRA. I just thought, 'We're talking about civil rights but we're perceived as the musical wing of the IRA'. How could you win against that?"

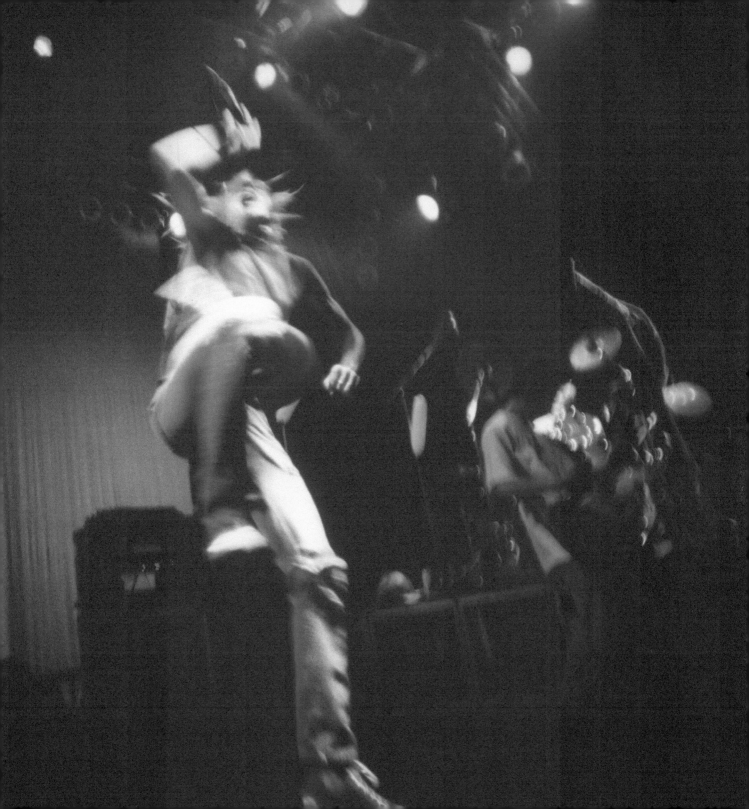

Óró 'sé do bheatha 'bhaile
traditional

Óró, sé do bheatha 'bhaile,
Óró, sé do bheatha 'bhaile,
Óró, sé do bheatha 'bhaile
Anois ar theacht an tsamhraidh.

'Sé do bheatha, a bhean ba léanmhar,
Do b' é ár gcreach tú bheith i ngéibheann,
Do dhúiche bhreá i seilbh méirleach,
Is tú díolta leis na Gallaibh.

Tá Gráinne Mhaol ag teacht thar sáile,
Óglaigh armtha léi mar gharda,
Gaeil iad féin is ní Gaill ná Spáinnigh,
Is cuirfidh siad ruaig ar Ghallaibh.

A bhuí le Rí na bhFeart go bhfeiceam,
Mura mbeam beo ina dhiaidh ach seachtain,
Gráinne Mhaol agus míle gaiscíoch,
Ag fógairt fáin ar Ghallaibh.

Leslie Dowdall (In Tua Nua) "I think that's one of the great things about Ireland, it's that women singers are very distinctive... there are very individual voices in Ireland, and I think that's a very important thing to keep."

30

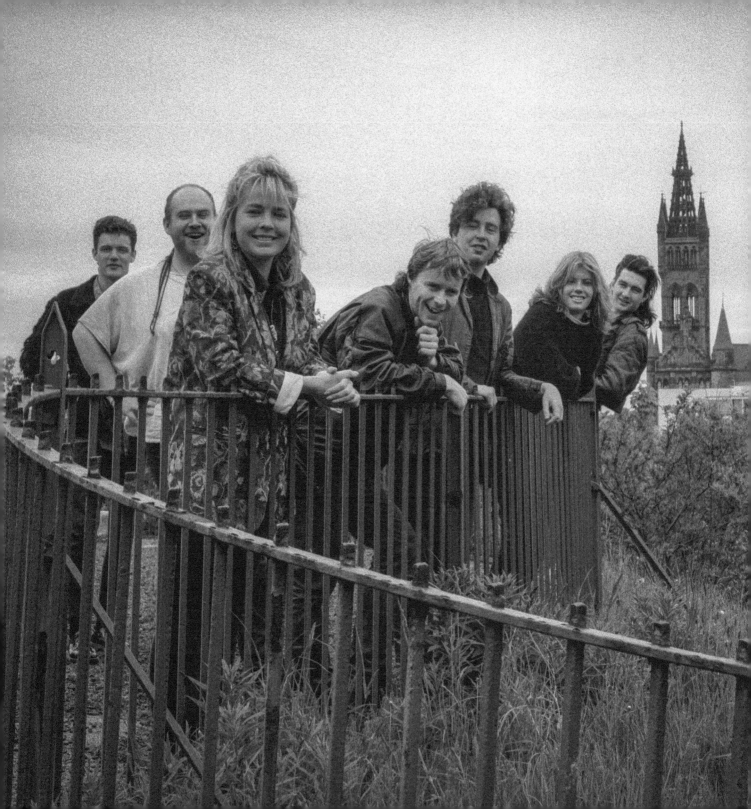

A Mother's Blessing
traditional

When Ireland is calling, Feargal, my boy,
What more can a fond mother do,
Only search in her heart and say with a sigh:
"God's blessing and mine be with you."
From Nazareth the road led to Calvary's Hill,
And HIS Mother then showed the way
A Mother should share in the cause of her Son
When destiny chooses the day.

When Ireland is calling, Feargal, my boy,
Her message comes but to the few.
Who, hearing His Voice in the tumult of Life.
Are ready to dare and to do.
Daring the might of aggression and power
To fearlessly right a grave wrong
"May God's Blessing and mine be with you, my boy,
And with Ireland to whom you belong.

Imelda May "I was from a great community, great people. But not the easiest of places. We had really hard times. There was no money about and lots of drugs.... Luckily, I came from a great family and had neighbours that were supportive. Eccentricity was highly encouraged. If I had a demo, the local fruit and veg man would say, 'Give us that tape and I'll make everybody listen to it'."

"Music, poetry and art are very normal parts of a working-class household. It shouldn't be seen as elitist... most people can recite to you their favourite poem. My dad read me Spike Milligan as a kid, and he'd act out each poem. He'd write poetry too. It was on both sides of my family. My mam's brother, my late uncle Joe Comerford, was a taxi driver – but he'd come over on his lunch break to sit down to read out his poems for me."

31

"I've got punk-rock in my bones. That's why I got into rockabilly, because it has those bones in it, too, y'know, the original rebelliousness."

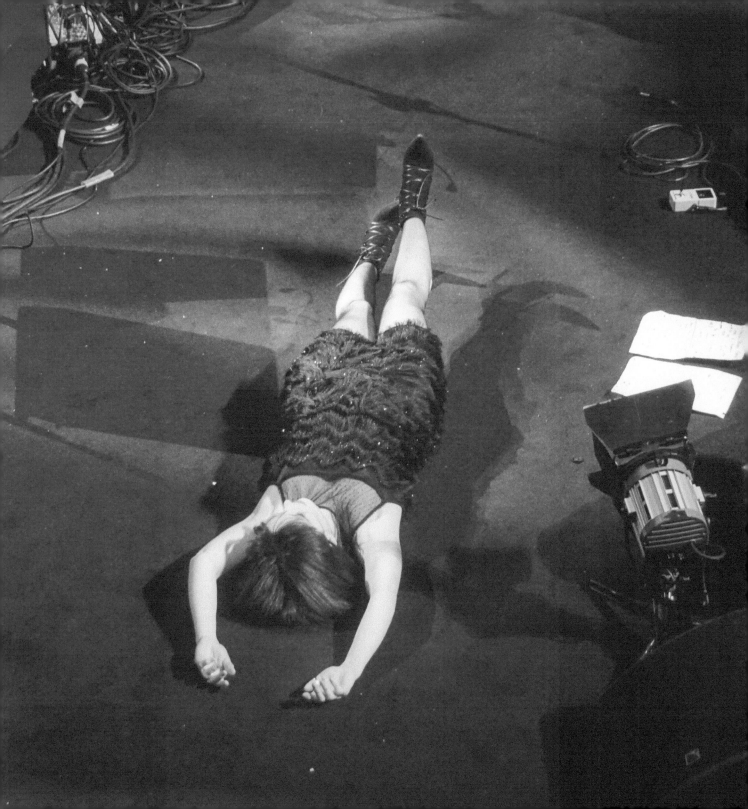

Birmingham Six
Shane MacGowan

There were six men in Birmingham
In Guildford there's four
That were picked up and tortured
And framed by the law
And the filth got promotion
But they're still doing time
For being Irish in the wrong place
And at the wrong time

John Lydon *"Poverty drove my parents out of Ireland. They moved to England thinking it was the best thing to do. They wouldn't teach me Gaelic. I thought it was a fascinating sounding thing. They looked for a new life — as is the case for many Irish."*

Shane MacGowan "When rock'n'roll was dying everywhere in the early '60s we were rocking on in Ireland. There was a lot of emigration over to England and people were bringing the records back. Actually, we were ahead of the game in the Swinging '60s. The farmers would play the latest records to milk the cows to. You get a bigger yield."

"Irish music is world music. You can hear it in Jamaica... When the West Indies broke free from England the West Indians said: "What the fuck are we doing, working for the English, slaving for these people?" They're into dancing and drinking and partying and the whole thing, so they've got more in common with the Irish than they have with the English. West Indians have got a similar culture to us, the positive and negative things - the guns and the rastafarianism and all that."

"I always hated London... I come from the generation that had to emigrate to find work. But fortunately enough for me it coincided with the Sex Pistols coming along so it made it worth being there."

32

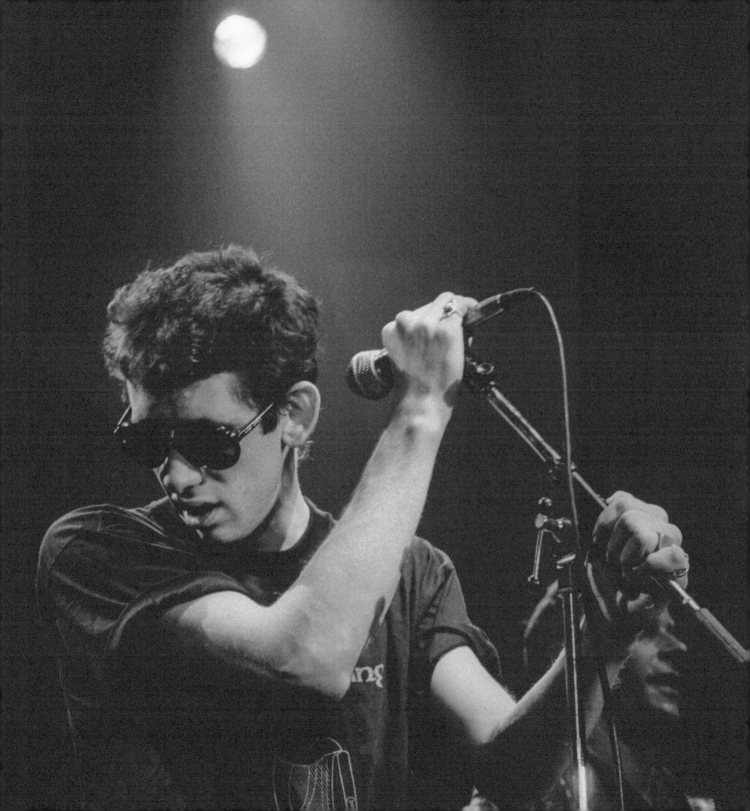

Philip King *"I have a recollection of filming Bringing It All Back Home in The Crown in Cricklewood 25 years ago and the look of loss and anger in people's faces... Songs like Tunnel Tigers or McAlpine's Fusiliers or Paddy Works On the Railway are eloquent and I remember Norma Waterson saying that these are our oral history. Emigration songs are like first person, emotional, eyewitness accounts shot through with love, loss and longing. The effect of a great emigration song is to compound the sense of loss and collapse the distance between the place you're in now and the place you've left behind."*

33

Johnny Cronin (Cronin) *"Song writing is like carpentry - you have to keep at it to learn the craft."*

"Growing up in Longford I was obsessed with Bowie, The Kinks and The Beatles and found it hard to get their music in the shops in Drumlish. When I moved to Leeds at 15 I got into The Smiths and the Happy Mondays but I found myself missing home and got obsessed with The Pogues and The Waterboys and Planxty."

The Black Velvet Band
traditional

In a neat little town they call Belfast
Apprentice to a trade I was bound
And many an hour's sweet happiness
Have I spent in that neat little town.
A sad misfortune came over me
Which caused me to stray from the land
Far away from my friends and relations
Betrayed by the black velvet band.

Her eyes they shone like diamonds
I thought her the queen of the land
And her hair it hung over her shoulder
Tied up with a black velvet band.

I took a stroll down Broadway
Meaning not long for to stay
When who should I meet but this pretty fair maid
Came a tripping along the highway
She was both fair and handsome
Her neck it was just like a swans'
And her hair is hung over her shoulder
Tied up with a black velvet band.

Her eyes they shone like diamonds
I thought her the queen of the land
And her hair hung over her shoulders
Tied up with a black velvet band.

I took a stroll with this pretty fair maid
And a gentleman passing us by
Well I knew she meant the doing of him
By the look in her roguish black eye
A gold watch she took from his pocket
And placed it right into my hand
And the very first thing I said was
Bad luck to the black velvet band.

Her eyes they shone like diamonds
I thought her the queen of the land
And her hair hung over her shoulders
Tied up with a black velvet band.

Before the judge and the jury
Next morning I had to appear
And the judge he said to me 'Young man
Your case it is proven clear'
We'll give you seven years penal servitude
To be spent far away from the land
Far away from your friends and companions
Betrayed by the black velvet band.

Her eyes they shone like diamonds
I thought her the queen of the land
And her hair hung over her shoulders
Tied up with a black velvet band.

So come all you jolly young fellows
A warning take by me
When you are out on the town me lads,
Beware of them pretty colleens
For they feed you with strong drink, "Oh yeah",
'til you are unable to stand
And the very next thing that you'll know is
You've landed in Van Diemens Land.

Her eyes they shone like diamonds
I thought her the queen of the land
And her hair hung over her shoulders
Tied up with a black velvet band.

34

Máire Brennan (Clannad) "There's so much interest in Irish music, dance, mythology and folklore. But people outside Ireland don't see the spiritual side of the Celtic race. Our ancestors' courage, love and humility came from their Christian background!"

"For me, it is important to make an issue of this. It's amazing how a race that has known such tragedy can make melancholy songs that are never dark! There's always a sense of hope and Irish is such a language for blessings!"

John Donoghue *"Irish field hands were the term-bound, chattel property of the planters who purchased them. They were itemised as the 'goods and chattels' of their masters on contracts and in estate inventories, beside 'negroes', livestock, hardware and other household goods. Like 'negroe' slaves, they could be sold again and again without their consent... Planters used 'servants', like slaves, as financial instruments to escape bankruptcy, to satisfy creditors, to liquidate estates, and to resolve debts and broken contracts."*

Charles Baily recalling his time on a Maryland tobacco plantation, wrote that *'hunger, cold, nakedness, beatings, whippings... laid many of his fellow labourers in the dust ... I am sure the poor creatures had better have been hanged, than to suffer the death and misery they did'.*

Liam Ó Maonlaí *"My father taught me to sing as I was learning to speak and the first song I learned was Buachaill Ón Éirne. My mum was a piano player so I used to mess around on the piano at home all the time, learning little melodies and tricks from different people."*

"My dad taught me Irish songs and language as a boy, and I'm rich for it. I don't know what I would be like without the language. He was a passionate man and had such a strong vision because he went to school with Seán Ó Riada, who I believe did more for the country than any man with a gun. Culture makes people look up, not down, and it lifts your head beyond the struggle."

35

David Nally *"The potato blight, Phythophthora infestans, was first recorded in Dublin in August 1845. Over the next five years the Irish potato harvest failed four times, triggering mass hunger and disease on a magnitude the European continent had not endured for centuries. During this period, over one million Irish perished and a further two million fled the land, never to return. Thus, in a relatively short period, three million people were dead or gone."*

"The Great Famine was shaped by a regulatory order that exploited catastrophe to further the aims of population reform. The Irish Poor Law system was based on principles that agricultural rationalization, fiscal restructuring, and population clearances were necessary to "ameliorate" and "improve" Irish society. It facilitated distinctions between productive and unproductive life and allowed the colonial state to apply its own sovereign remedy to Irish poverty."

36

Shane MacGowan *"The most important thing to remember about drunks is that drunks are far more intelligent than non-drunks – they spend a lot of time talking in pubs, unlike workaholics who concentrate on their careers and ambitions, who never develop their higher spiritual values, who never explore the insides of their head like a drunk does."*

Ronnie Drew *"Shane is a great songwriter, I sing a song of his about the famine... I never know how bad Shane is or how drunk he is because whenever I chat to him he's always very lucid."*

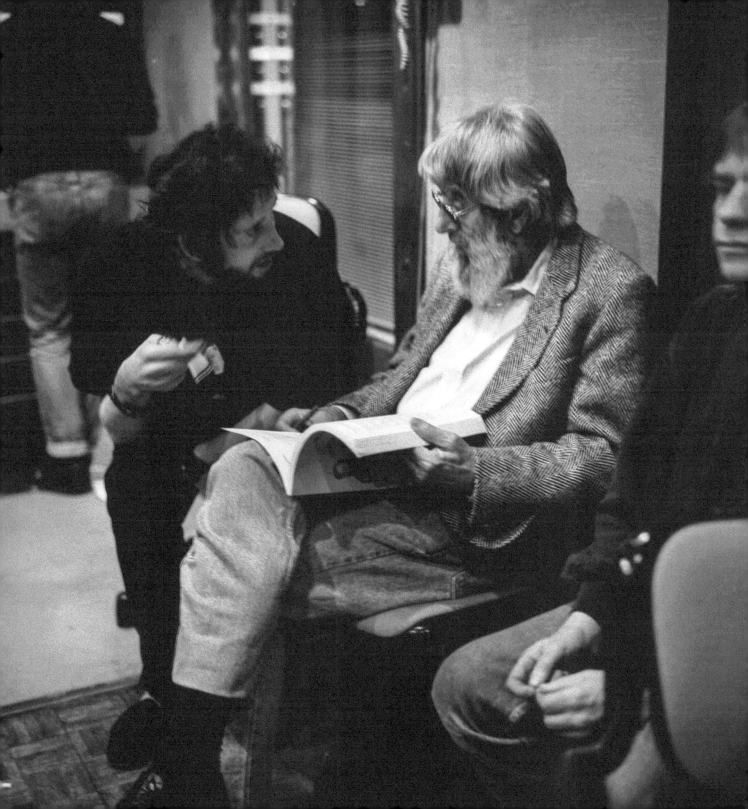

"Hear the rebels' voices calling
'I shall not die, though you bury me!'"

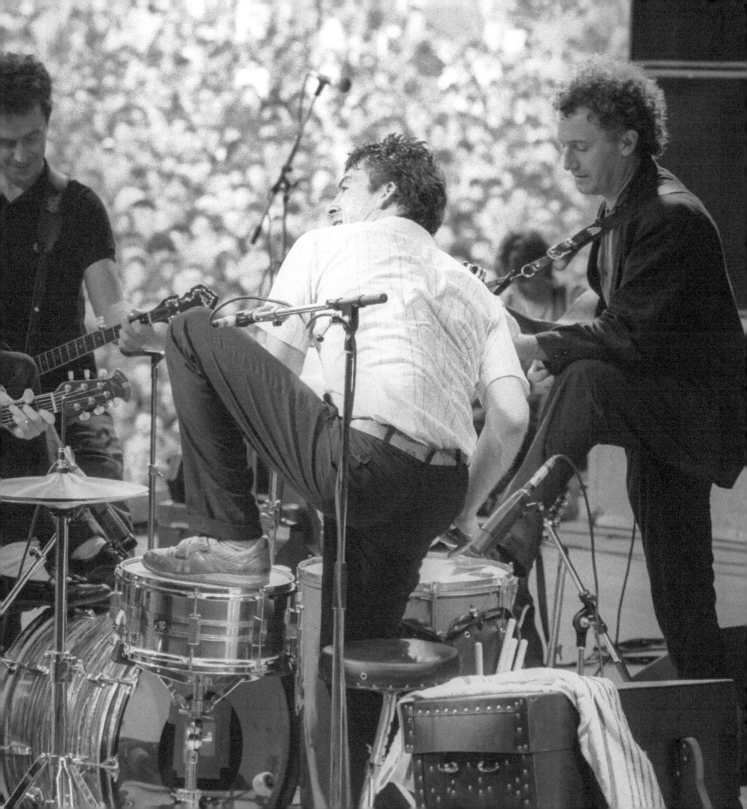

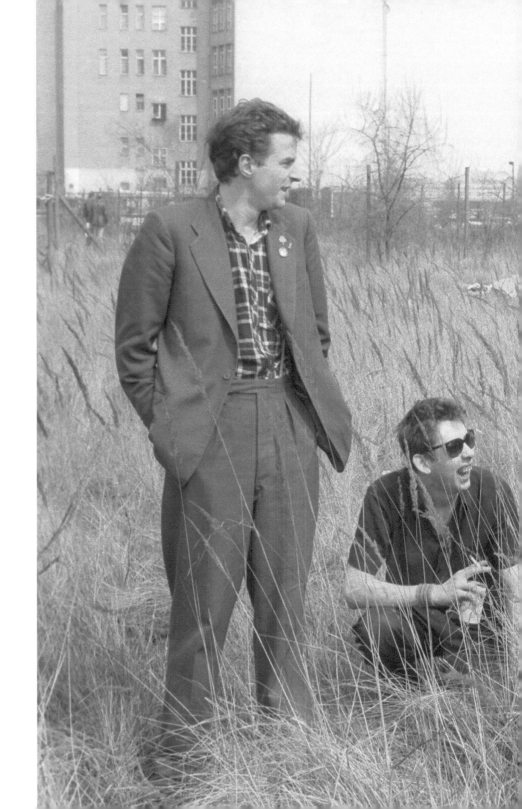

Shane MacGowan "...your roots hang onto you, you don't hang onto them."

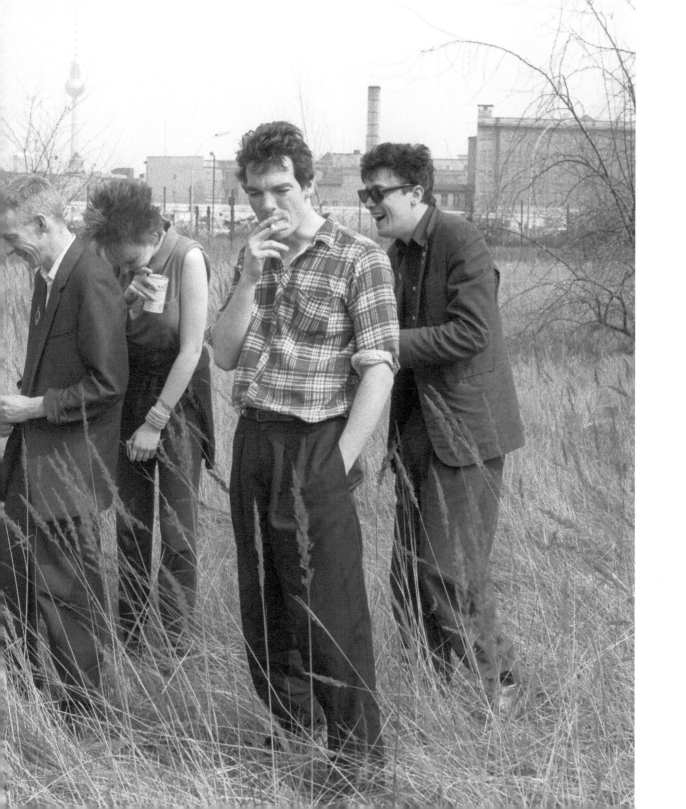

Kevin Devine (Socialist Review) *"Music lover and DJ extraordinaire John Peel had one pop song that he regarded above all others. At his personal request it was played at his funeral, and its opening line ('Teenage dreams, so hard to beat') is inscribed on his gravestone. The song is 'Teenage Kicks', the first single released by the Undertones."*

Damian O'Neill (The Undertones) *"The older you get the more you realise we were all very affected by it without realising; perhaps scarred in a way. Awful things happened. Nobody in our respective families got killed or anything, nobody got put in jail, but you lived it day to day, and it became normalised. Getting searched going into town, road blocks and bombs going off and hearing shooting. But we didn't want to dwell on that. Our escape from that was forming a band and singing about unrequited love. At that time we were so sick of the Troubles we didn't want to talk about it or sing about it."*

39

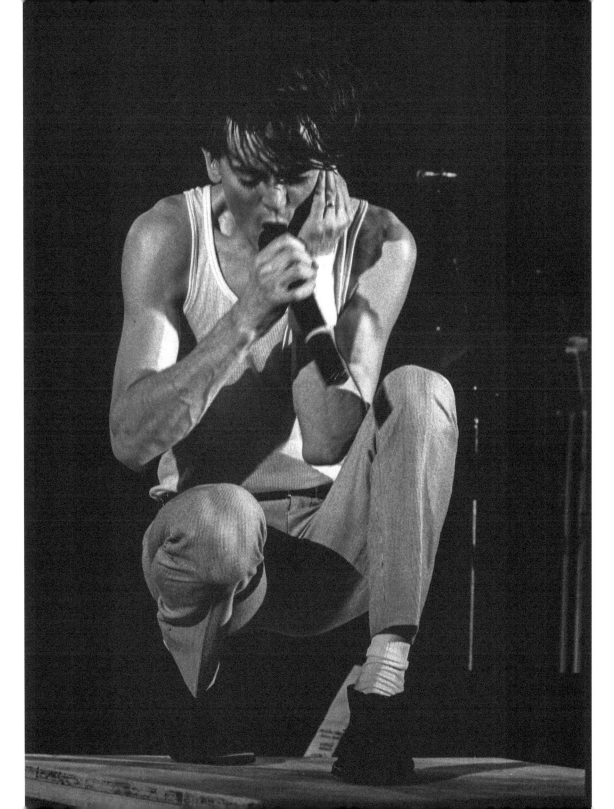

Jeff Giles (Rolling Stone) *"About fifteen minutes outside Belfast, Hothouse Flowers' van comes upon one of Northern Ireland's makeshift military blockades. It is one o'clock in the morning, and the Dublin group — whose first record, 1988's People, was the most successful debut in Irish history — is returning home from a particularly joyous gig. Now, with a soldier approaching, the mood in the van has turned tense. "Here we go," the driver says, fishing around for identification.*

Fortunately, after a few terse preliminaries, it becomes clear that the soldier recognizes the band. "Where have you been playing?" he asks Liam O'Maonlai, the group's soft-spoken twenty-five-year-old singer and pianist.

"The Belfast Opera House," O'Maonlai tells him.

"How was it?"

O'Maonlai grins and shakes his head. "You should have been there," he says...

Now, as the van moves away from the blockade, O'Maonlai says, "The North is a special place to play. Bands just don't play there as regularly as they do the rest of the country, because it's got a name for being a violent place. So the people are starved, in a way."

"In America, people come up and try to get on my good side by saying, 'Are you Protestant or Catholic?' They wait for me to say, 'Catholic,' and then they launch into their pro-IRA bit. Now I just say, 'I'm not telling you, because I'm not getting involved. Nobody's right anymore.'"

40

Liam Ó Maonlaí (Hothouse Flowers) *"The one thing I was blessed with was that I saw traditional music had its own infinite power and integrity.... I was as awe-inspired to hear somebody late at night in West Kerry singing a song as I would be by anything else, maybe more so, because of the nature of it, the timelessness."*

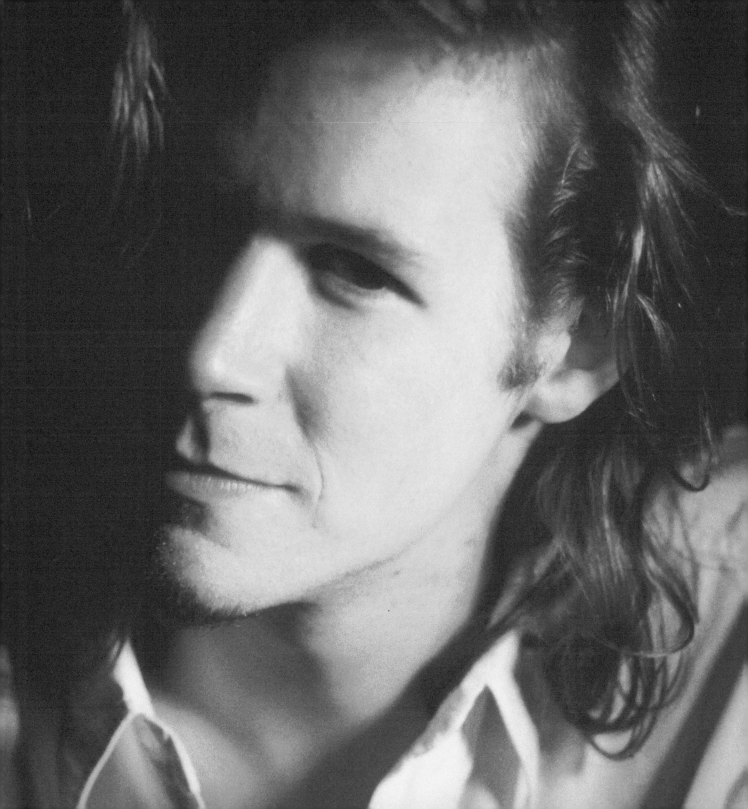

A Nation Once Again
Thomas Osborne Davis

When boyhood's fire was in my blood
I read of ancient freemen,
For Greece and Rome who bravely stood,
Three hundred men and three men;
And then I prayed I yet might see
Our fetters rent in twain,
And Ireland, long a province, be
A Nation once again!

A Nation once again,
A Nation once again,
And Ireland, long a province, be
A Nation once again!

And from that time, through wildest woe,
That hope has shone a far light,
Nor could love's brightest summer glow
Outshine that solemn starlight;
It seemed to watch above my head
In forum, field and fane,
Its angel voice sang round my bed,
A Nation once again!

A Nation once again,
A Nation once again,
And Ireland, long a province, be
A Nation once again!

It whisper'd too, that freedom's ark
And service high and holy,
Would be profaned by feelings dark
And passions vain or lowly;
For, Freedom comes from God's right hand,
And needs a Godly train;
And righteous men must make our land
A Nation once again!

A Nation once again,
A Nation once again,
And Ireland, long a province, be
A Nation once again!

So, as I grew from boy to man,
I bent me to that bidding
My spirit of each selfish plan
And cruel passion ridding;
For, thus I hoped some day to aid,
Oh, can such hope be vain?
When my dear country shall be made
A Nation once again!

Ronnie Drew (The Dubliners) *"I wouldn't call myself an actor or a singer for that matter, just a journeyman. I feel I must have a talent somewhere for doing something but I'm still not terribly sure what it is. I suppose it's a talent for being myself."*

"I've always considered myself a failure: I feel I've never done anything wholly right. Everybody will tell you, 'Oh no, how can you say that, because ten thousand people clap you on a night?' But part of that is reflex action and part of it is because you're reasonably good. But if you're great, that's a different thing."

41

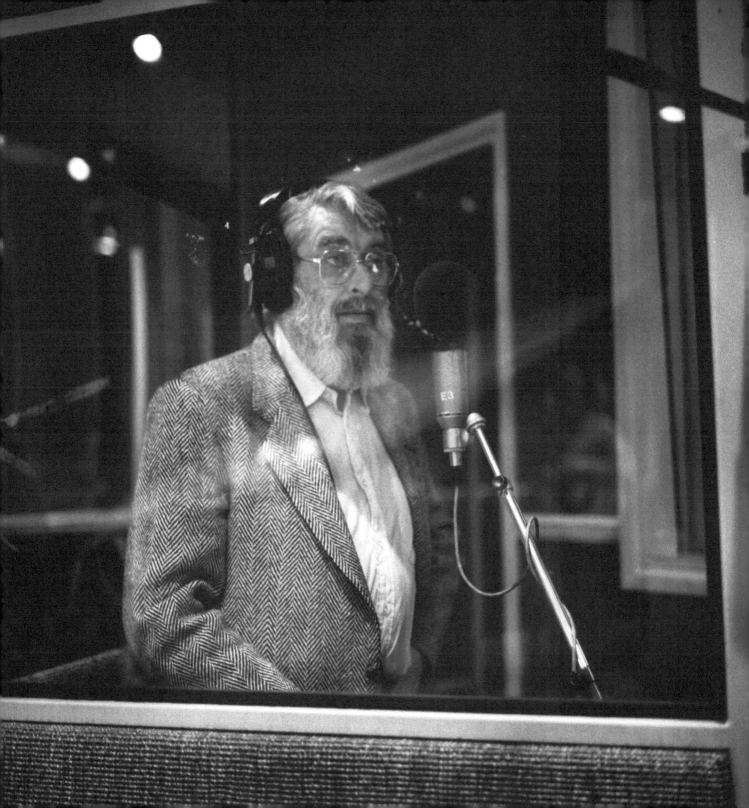

The Irish Rover
traditional

On the 4th of July, 1806
We set sail from the sweet cove of Cork
We were sailing away with a cargo of bricks
For the Grand City Hall in New York

'Twas a wonderful craft, she was rigged fore and aft
And oh, how the wild wind drove her
She stood several blasts, she had twenty seven masts
And they called her The Irish Rover

We had one million bags of the best Sligo rags
We had two million barrels of stone
We had three million sides of old blind horses hides
We had four million barrels of bones

We had five million hogs and six million dogs
Seven million barrels of porter
We had eight million bails of old nanny-goats' tails
In the hold of the Irish Rover

There was awl Mickey Coote who played hard on his flute
When the ladies lined up for a set
He was tootin' with skill for each sparkling quadrille
Though the dancers were fluther'd and bet

With his smart witty talk, he was cock of the walk
And he rolled the dames under and over
They all knew at a glance when he took up his stance
That he sailed in The Irish Rover

There was Barney McGee from the banks of the Lee
There was Hogan from County Tyrone
There was Johnny McGurk who was scared stiff of work
And a man from Westmeath called Malone

There was Slugger O'Toole who was drunk as a rule
And Fighting Bill Treacy from Dover
And your man, Mick MacCann from the banks of the Bann
Was the skipper of the Irish Rover

We had sailed seven years when the measles broke out
And the ship lost its way in the fog
And that whale of a crew was reduced down to two
Just myself and the Captain's old dog

Then the ship struck a rock, oh Lord, what a shock
The bulkhead was turned right over
Turned nine times around and the poor old dog was drowned
I'm the last of The Irish Rover

42

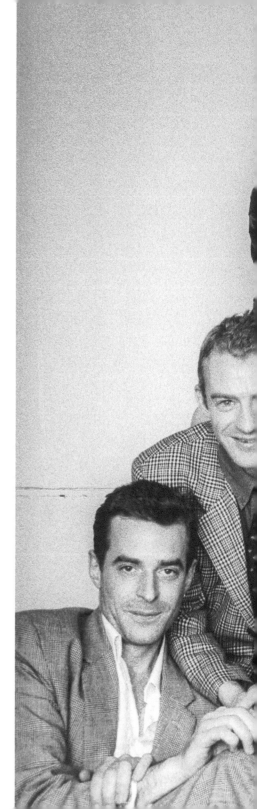

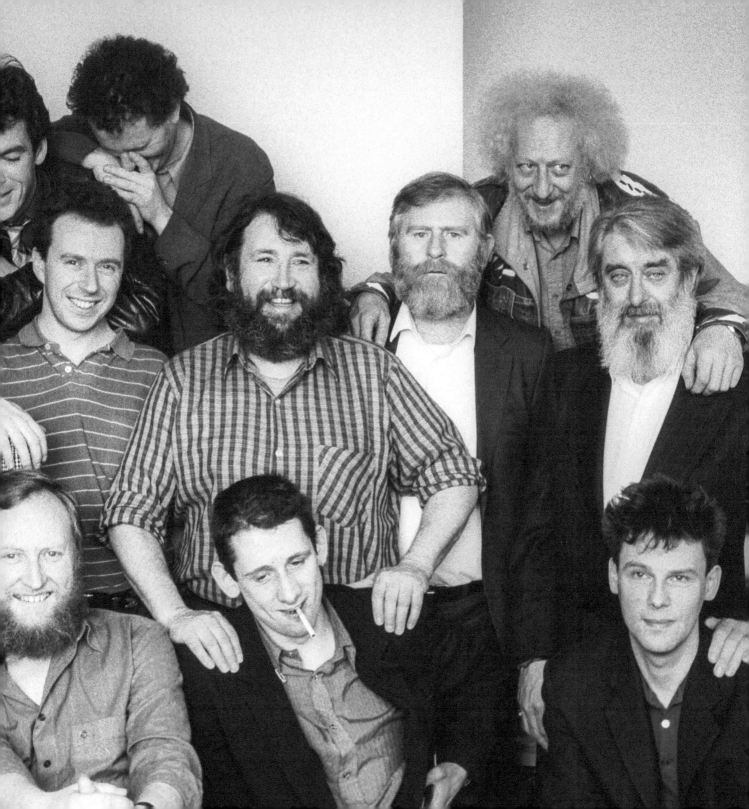

September 1913
W B Yeats

What need you, being come to sense,
But fumble in a greasy till
And add the halfpence to the pence
And prayer to shivering prayer, until
You have dried the marrow from the bone;
For men were born to pray and save;
Romantic Ireland's dead and gone,
It's with O'Leary in the grave.

Yet they were of a different kind,
The names that stilled your childish play,
They have gone about the world like wind,
But little time had they to pray
For whom the hangman's rope was spun,
And what, God help us, could they save?
Romantic Ireland's dead and gone,
It's with O'Leary in the grave.

Was it for this the wild geese spread
The grey wing upon every tide;
For this that all that blood was shed,
For this Edward Fitzgerald died,
And Robert Emmet and Wolfe Tone,
All that delirium of the brave?
Romantic Ireland's dead and gone,
It's with O'Leary in the grave.

Yet could we turn the years again,
And call those exiles as they were
In all their loneliness and pain,
You'd cry `Some woman's yellow hair
Has maddened every mother's son':
They weighed so lightly what they gave.
But let them be, they're dead and gone,
They're with O'Leary in the grave.

43

Mike Scott (The Waterboys) "Well, you know I came here 31 years ago because Steve Wickham invited me. And I enjoyed it, I felt at home. It felt creative, music was everywhere, it was easygoing. I liked the Irish imagination... It was a parallel universe. I felt like I'd gone through the looking glass, and I loved it. I don't still have the same romantic notions of Ireland that I had perhaps when I came here first, because I've seen all kinds of Irish life now, but I feel very at home here. I write well here, I like the people."

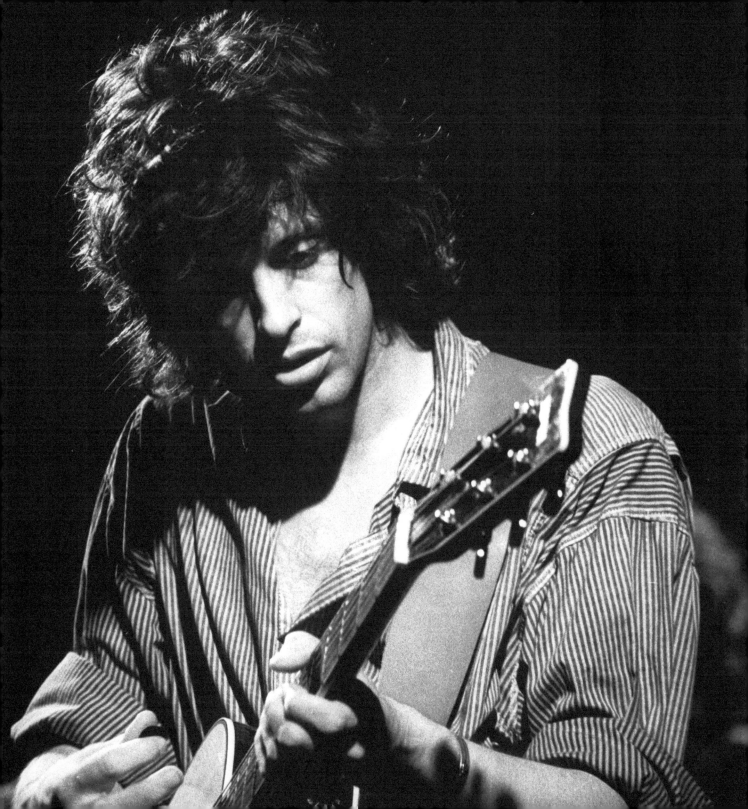

Frederick Douglass, a former African-American slave turned abolitionist, who toured Ireland in 1845, compared the songs he had heard in Ireland to those he remembered hearing among the slaves when he was a child:

"I have never heard any songs like those anywhere since I left slavery, except when in Ireland. There I heard the same wailing notes, and was much affected by them. It was during the famine of 1845-6. Nowhere outside of dear old Ireland, in the days of want and famine, have I heard sounds so mournful."

Bono *"...the biggest obstacle to political and social progress was... a combination of our own indifference and the Kafkaesque labyrinth of 'no's you encounter as people vanish down the corridors of bureaucracy."*

"I'm not a hippy, I do not have flowers in my hair, I come from punk rock, The Clash wore army boots not Birkenstocks."

"Every age has its massive moral blind spots. We might not see them, but our children will. Slavery was one of them and the people who best served that age were the ones who called it as it was — which was ungodly and inhuman."

"The scale of the suffering and the scope of the commitment they often numb us into a kind of indifference.... We can't fix every problem — but the ones we can we must. The debt burden, unfair trade, sharing our knowledge, the intellectual copyright for lifesaving drugs in a crisis, we can do that. And because we can, we must."

44

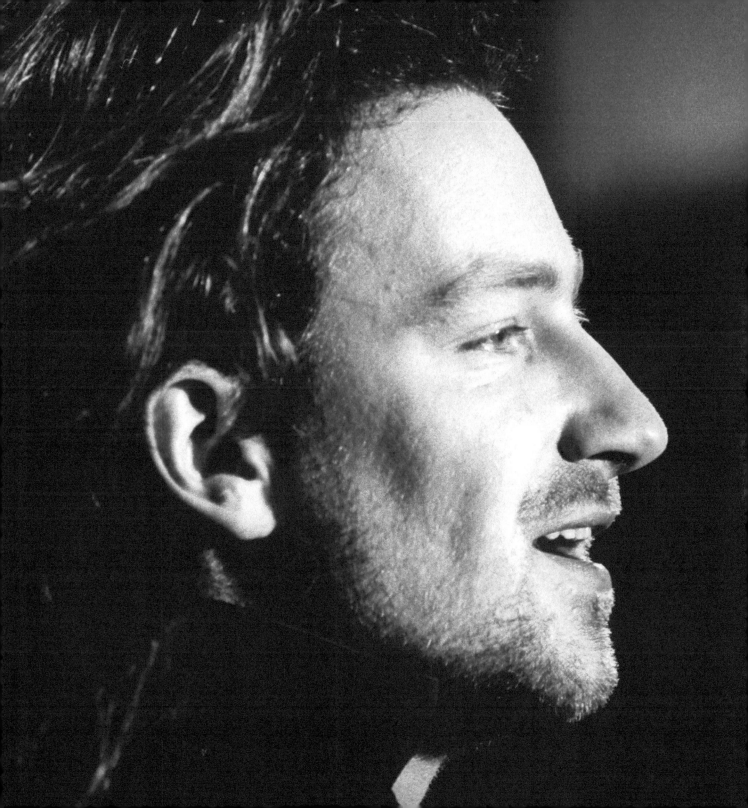

Black and Tans
Dominic Behan

I was born on a Dublin street where the Royal drums do beat
And the loving English feet they tramped all over us,
And each and every night when me father'd come home tight
He'd invite the neighbours outside with this chorus:

So come out you black and tans,
Come out and fight me like a man
Show your wife how you won medals down in Flanders
Tell them how the IRA
Made you run like hell away,
From the green and lovely lanes in Killashandra

Come let me hear you tell
How you slandered brave Pernell,
How you fought him well and truly persecuted,
Where are the sneers and jeers
That you loudly let us hear
When our leaders of sixteen were executed

Come tell us how you slew
Them old Arabs two by two
Like the Zulus they had spears and bows and arrows,
How you bravely faced each one
With your sixteen pounder gun
And you frightened them poor natives to the marrow

Allen, Larkin, and O'Brien--
How you bravely called them swine!
Robert Emmett who you hung and drew and quartered!
High upon that scaffold high,
How you murdered Henry Joy!
And our Croppy Boys from Wexford you did slaughter!

The day is coming fast
And the time is here at last,
When each yeoman will be cast aside before us,
And if there be a need
Sure my kids will sing, "Godspeed!"
To a verse or two of Steven Beehan's chorus

45

Bono "*The thing about The Dubliners is — line 'em up, the hardest rock'n'roll bands in the world, AC/DC, Led Zeppelin, The Who, Oasis, Nirvana, U2 — we're all a bunch of girls next to The Dubliners.*"

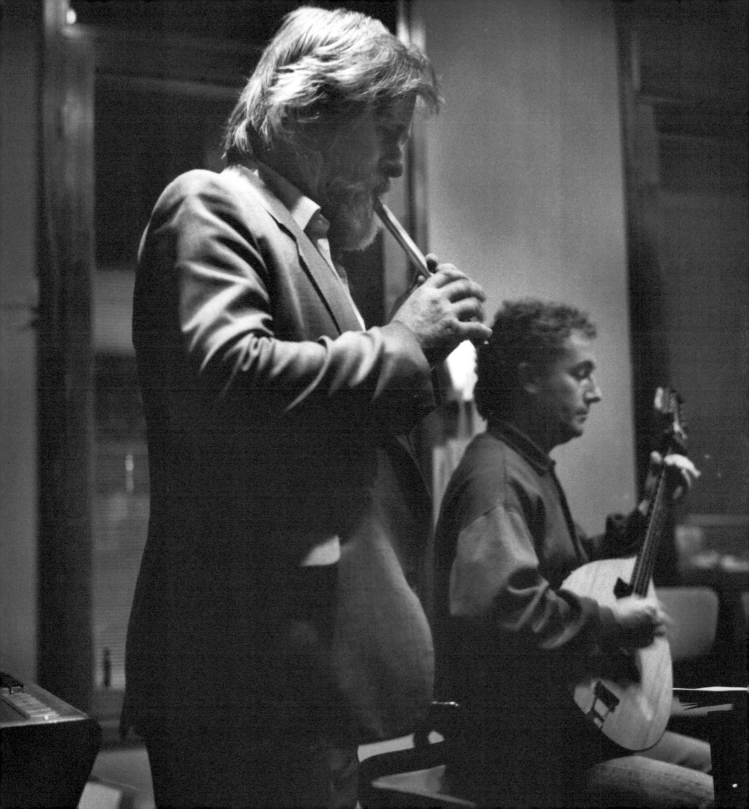

Daniel Sheehan (Irish Party MP and Captain in the British Army, to the House of Commons in 1918 in response to conscription of Irish men.)

"You state that you are fighting for justice, freedom and liberty. It was in the belief this country was fighting for those principles that I and others offered our services in the earlier months of the War. I ask what freedom, what justice, or what liberty is the Irish conscript going to get?"

"The officers were a horde of English Cockneys... A similar pledge was given in the case of Carson's army, and it was observed; but it was not observed in the case of the Irish Brigade.... I tell you that you may take our men at the point of a bayonet – you will not get them in any other way, but you will not succeed in killing the spirit of Irish nationality, and at the end you will find you have lit a flame which is not likely to die out in our generation."

"You have not trusted Irishmen. You have not dealt fairly with them since this war broke out. You have heaped insults and humiliations upon them... I remember reading with horror what I regarded as a butchery of a Labour leader in Dublin in Easter Week. Although he was not able to stand up to be shot, although he was wounded, if he had been a soldier serving in any other part of the world he would have received the honour due to a soldier, but he was brutally butchered, maimed and mangled. You are teaching us once again that we cannot trust you, and that if we are to exist as a nation we must fight for our nationality... That is a right which we Irishmen are asserting for our people, and if need should arise, we will be ready to seal it with our blood."

46

Joseph O'Connor "I think Ireland couldn't have been transformed without that sort of group of musicians – U2 and the Boomtown Rats and Sinead O'Connor, my sister, and the earlier people like Rory Gallagher. I think those people changed their country and changed their society for the better..."

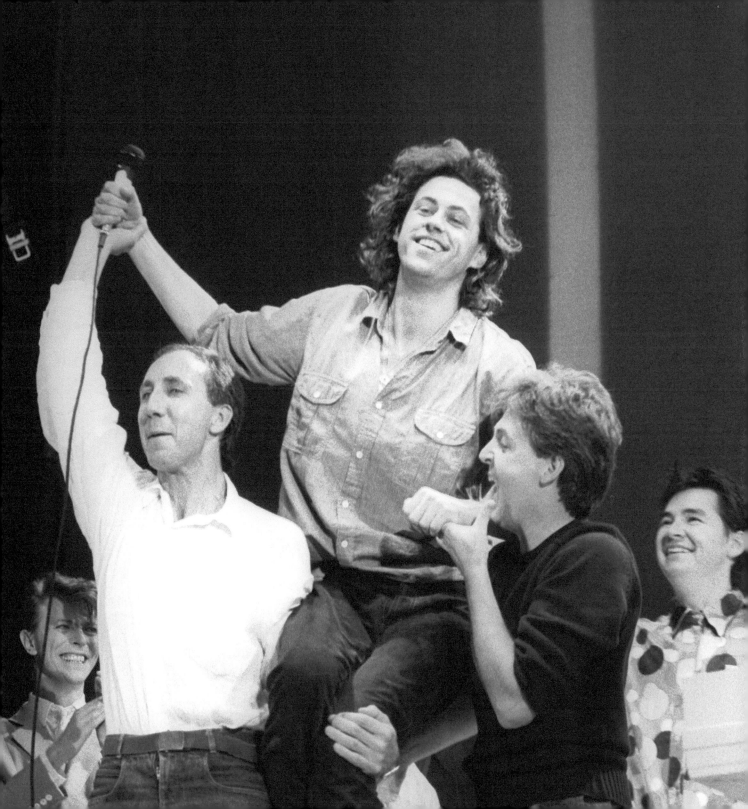

Time Has Come
Christy Moore/Donal Lunny

The time has come to part, my love,
I must go away
I leave you now, my darling girl,
No longer can I stay.

My heart like yours is breaking
Together we'll prove strong
The road I take will show the world
The suffering that goes on.

The gentle clasp that holds my hand
Must loosen and let go
Please help me through the door
Though instinct tells you no.

Our vow it is eternal
And will bring you dreadful pain
But if our demands aren't recognised
Don't call me back again.

How their sorrow touched us all
In those final days
When it was the time she held the door
And touched his sallow face...

47

Christy Moore "Forty years ago, my life in music was substantially different to today. I went out every night with my guitar seeking a place to sing, a floor on which to lie, some love, some food, a lot of wine. There was no business, no gigs, no questions, no P.R., recording, life was simpler, I was poor and young and hungry. Today I am a lot more focused on the song."

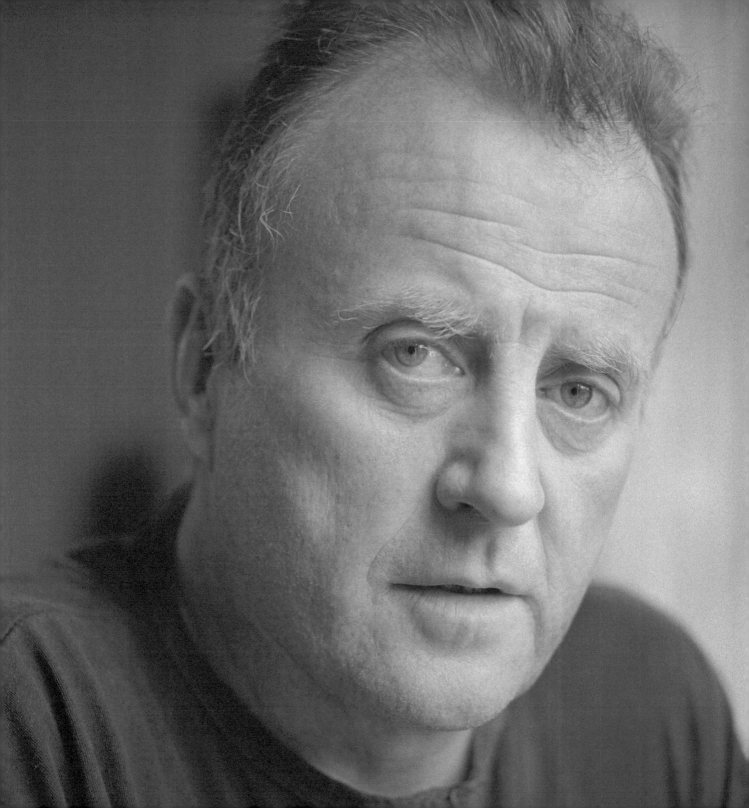

Grace Toland *"The biggest employer in Inishowen is emigration. It's built in and it's in your head. You know you're going to go away to school and to work and you might come back or you might not come back so singing about those things is normal. It's as much about singing about being in love or history or politics or any of the other great things we sing about. You can be funny about or you can lament it or you can report it, but you do it."*

Philip King *"Songs will remain a great source of succor and a very eloquent requiem for a loneliness. It's important to think about what the song can now do in a world which has become virtual. It can collapse that distance in a way which is very human and tactile and emotional. What I hear in the brilliance of the Irish community that produced the Morrisseys, the Johnny Marrs, the John Lennons, the Gallaghers is all of that. I think what makes their songs absolutely stunningly engaging is that shot of lonesomeness."*

Tom McManamon *" A lot of the time when he's sitting at the bar, he's thinking, working, writing on fag boxes; he remembers everything; he's got one of the finest memories I've ever known. Shane is musically very astute. Shane's melody is one of his strongest points – he just does something sometimes and you think to yourself, where the hell did that come from? "*

48

Nick Cave *"I regard Shane as easily the best lyric writer of our generation. He has a very natural, unadorned, crystalline way with language. There is a compassion in his words that is always tender, often brutal, and completely his own."*

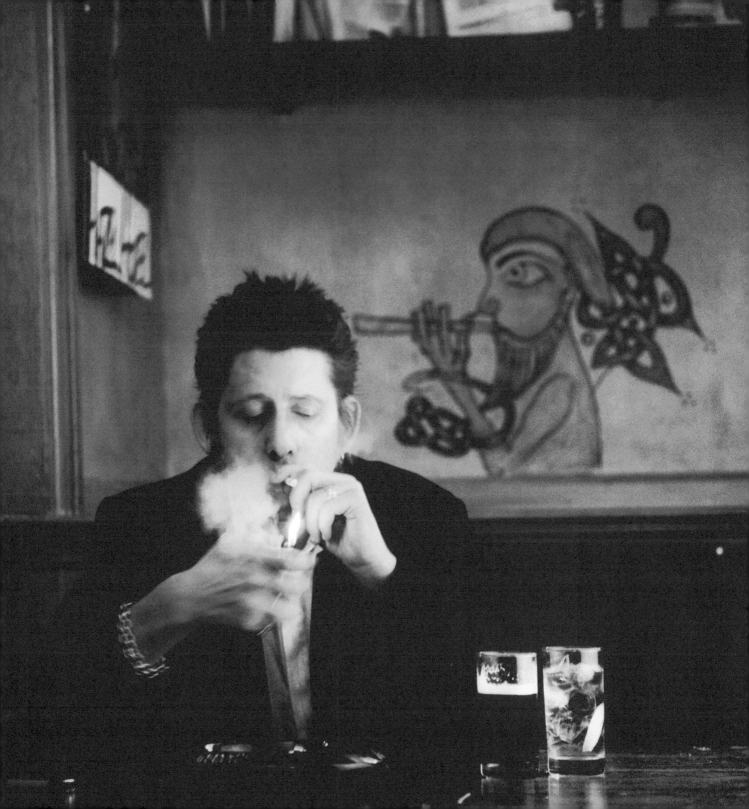

Max Hastings *"Should the Scots and Northern Irish go, given that the English have most of the people and the wealth, there is no logical reason why a future England should cut any slighter a figure on the world stage than does Britain today. Yet I believe that we should nonetheless be diminished; that what is left would seem, to other nations and governments, less significant."*

49

Shane MacGowan *"If you're asking whether drink and drugs have worked for me, I've got to say they have. I'm at one with William Blake on this one. Drink and drugs and all that shit, it's a short cut to the subconscious."*

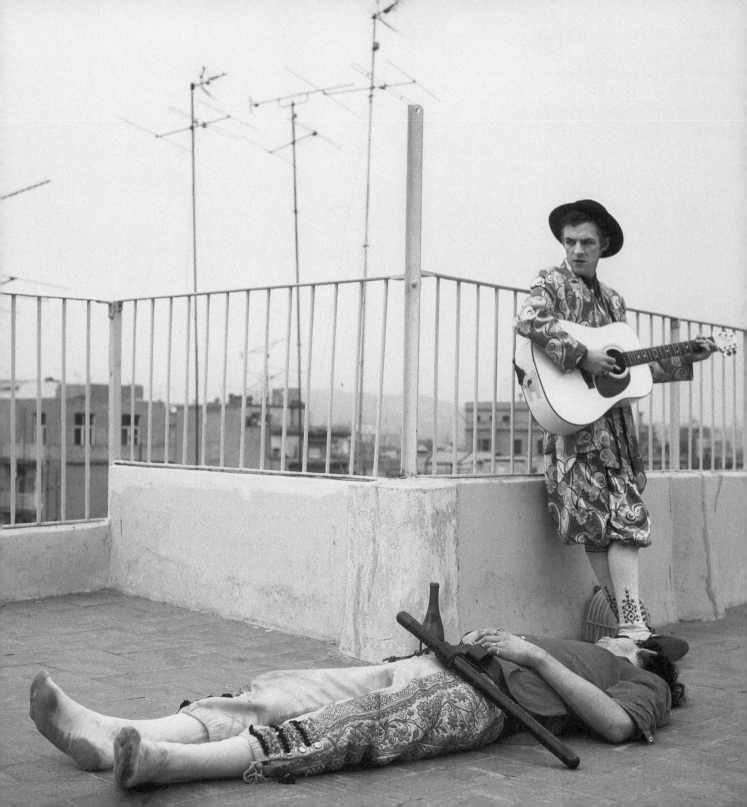

Ronnie Drew tells a story about Behan's exploits in Spain: "*'I have come for the funeral of General Franco.' Brendan told horrified Spanish police, who informed him that the generalissimo was not yet dead. 'I'll wait.' said Behan, before being unceremoniously deported.*"

50

Shane MacGowan "The mind police set up rules for music and the Fureys broke all that down. They broke every bloody rule. Finbar Furey was the first born to an old travelling family. His father, Ted Furey, was a famous fiddle player. There were loads of travelling musicians and bards and all that all over Ireland. The real point is that we're all in this shit together, yeah? Unless you're a landowner or a particularly spineless bastard, you're part of this stream of thought that includes people like Yeats and Joyce and Finbar Furey and you know... they all agreed on one thing: that we should decide what went on here, that the Irish people should decide."

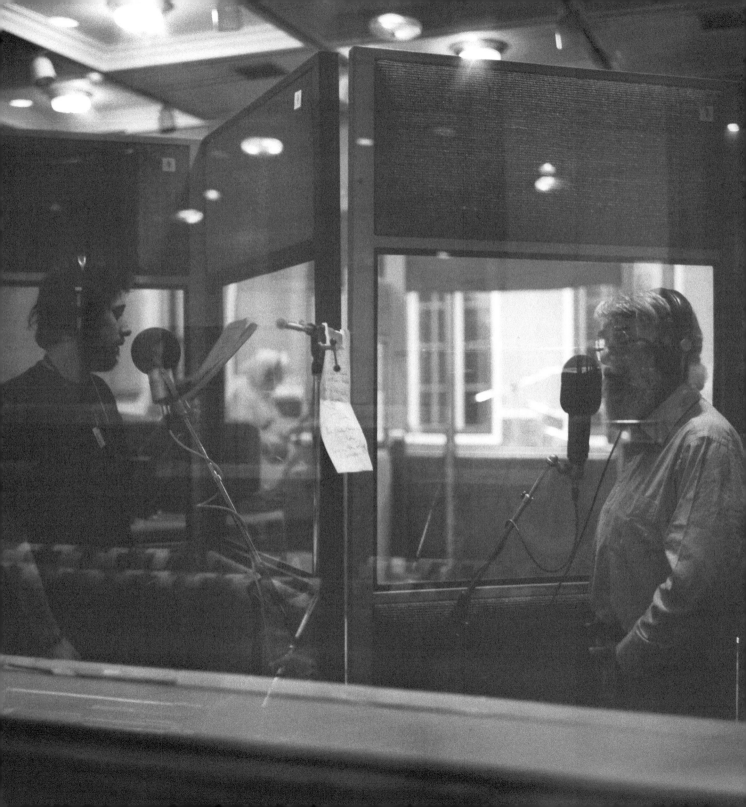

In 2004 Christy Moore was detained by customs officials: *"My driver and I were stopped and held for two hours at Holyhead last Monday, under the Prevention of Terrorism Act 2002. My driver and I were held separately in two interrogation rooms. I was questioned about the contents of my briefcase. I was questioned about lyrics of songs and I was asked a lot of personal questions about members of my family and my children and about my home. At no time was I given any explanation as to why I was being held and interrogated in this manner."*

Christie Moore was named Ireland's greatest living musician by the Irish television company, RTÉ, in 2007.

51

Christy Moore "If I had to live again I would do exactly the same thing. Of course I have regrets, but if you are 60 years old and you have no regrets then you haven't lived."

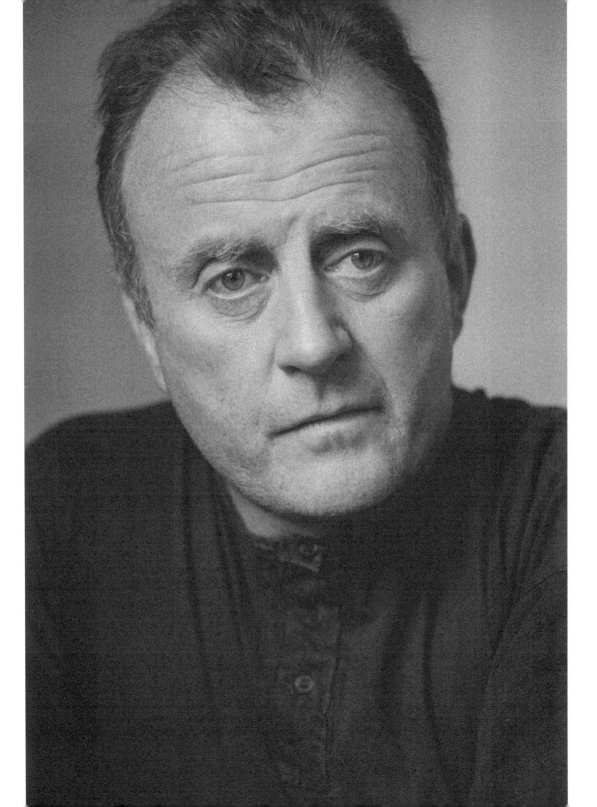

Finbar Furey

She sleeps beside my Galway Bay
My smiling girl so dear to me
I dug her grave with my bare hands
and let my tears fall with the land
There was no pride left in dying young
with hope's sweet life and future gone
so I made my way to the leaving Quay
and said farewell to my Galway Bay.
Ashamed the day my heart and pain
I'd have died for sure should I remain
This blight had taken many lives
and would kill us all man woman and child
So little we had, so much to loose
No time for prayer no one to choose
but in my heart you will always stay
my smiling girl, Galway Bay
I left the Bay and I felt the still
where my Maggie sleeps beneath the hill
and above goodbyes a seagull cried
while the tears of going they filled my eyes
May your heart and me forever shine
from where you sleep on my Erin's Isle
and when I'm dreaming far away
I'll dream with you Maggie and my Galway Bay.

Finbar Furey *"Irish music is a wild spirit anyway you know . You take it as it comes ... once I take the pipes up and I let fly, I don't know where I'm going and if I make it, I make it and if I don't, I don't."*

"I learned my music by sitting beside my Father and my uncles and great pipers like Felix Doran and all the great ones like Willie Clancy who slept in the house when we where kids. I grew up beside these people and slept in the same beds as them when I was only a kid so the music comes from them and my Father and from the likes of the Dorans. Great and wonderful musicians. Wild wild men and wild wild music."

"That's where it comes from. It comes from the heart doesn't it. That's the difference with a lot of Irish musicians. They play not as it is written but as they feel it. Like you can bend one note into three on a whistle or even on a box accordion. It could never read that way, it just how that piece of music feels. You can't trap Irish music on paper."

"Sure I've met all these old guys and women too who have been away from Ireland for so long that they've nothing to go back home to, and this is the excuse they use: 'Ah sure there's nothing back there for me now you know' and they're only dying to get home. The great truth is a lot of them never went back because they never really made it you know. They would have loved to have gone back but their pride kept them away. I love that pride. That's a wonderful pride that we have".

52

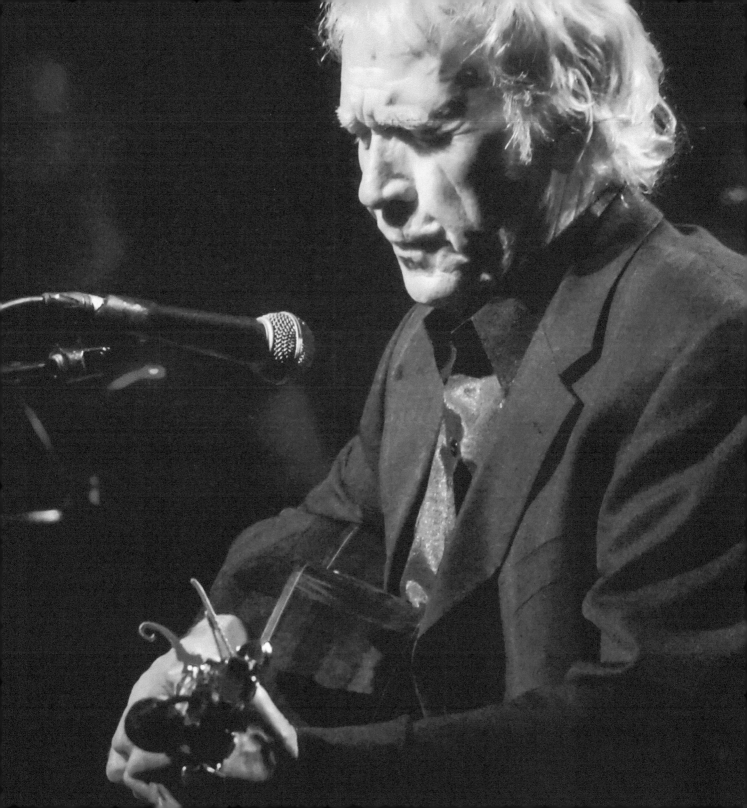

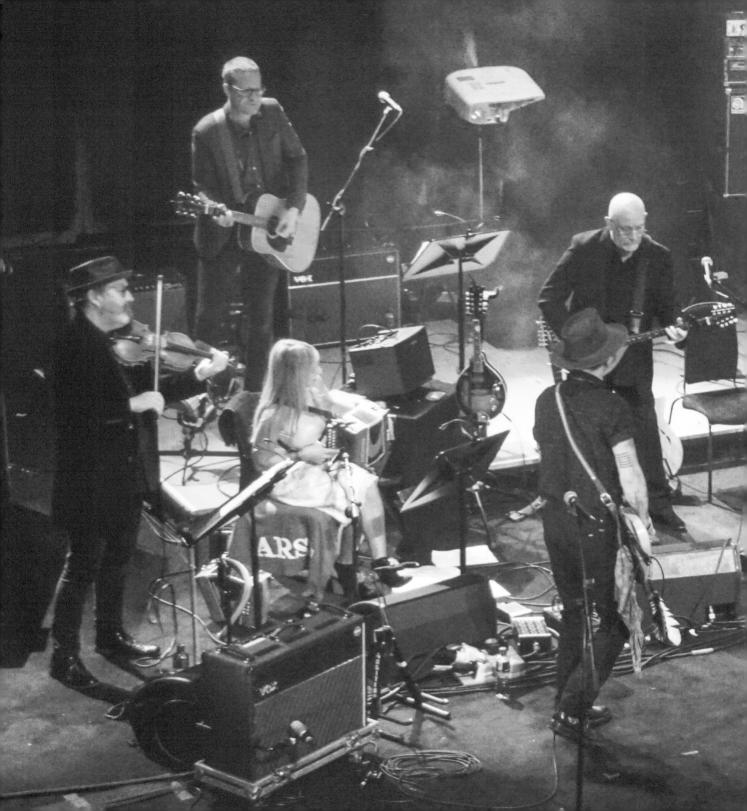